Defining Edges

A NEW LOOK AT
PICTURE FRAMES

A NEW LOOK AT PICTURE FRAMES

W. H. Bailey

FOREWORD BY ADAM GOPNIK

Defining
Edges

HARRY N. ABRAMS, INC., PUBLISHERS

EDITOR: Barbara Burn
EDITORIAL ASSISTANT: Josh Faught
DESIGNER: Sam Potts, Eric Baker Design Associates
PHOTO RESEARCH: Carousel Research, Inc.
PRODUCTION COORDINATOR: Maria Pia Gramaglia

Library of Congress Cataloging-in-Publication Data

Bailey, W. H.
Defining edges : a new look at picture frames / W. H. Bailey ;
with a foreword by Adam Gopnik.
p. cm.
ISBN 0-8109-4489-8
1. Picture frames and framing. I. Title.
N8550 .B33 2002
749'.7 — dc21 2002005144

PRINTED AND BOUND IN SPAIN
10 9 8 7 6 5 4 3 2 1

Harry N. Abrams, Inc.
100 Fifth Avenue
New York, N.Y. 10011
www.abramsbooks.com

ABRAMS IS A SUBSIDIARY OF

CONTENTS

A FRAME

Adam Gopnik

The frame of a picture is usually seen as something like the binding of a book—at worst a distraction, at best an honorific, there to indicate a period, a style, an attitude to life, or just to be a showy gilded thing. That we think this, unreflectively, is perhaps a sign of the depth of our prejudice against the visual, for the frame, after all, is right there in the way, right there in view. You look at a binding before you read a book, but you look at a frame while you're looking at a picture. A frame is something seen wrapped around something seen, and changing it changes the meaning of what it encloses, as words alone can change words. A frame is not even like the typeface of a book, which, for the most part, everyone reads right past save for the person who chose it. A frame is more like the book's introduction, its preface, the thing that sets the context in which the work must be understood. The important difference, though, is that the frame is a preface that wraps right around the book, lending it its own meaning at every moment—as though, terrible thought, this foreword were inescapable and intruded its own voice in every chapter of the book it superintends.

Given this responsibility, the only confidence I have in my own ability to put an edge around this text derives from my work with Bill Bailey, the author of this book. For Bailey understands frames as writers dream of grasping epigraphs and introductions, as commentary, italics, and ironic envelope. From Bailey, a small group of people, those who have been lucky enough to be his students or admirers or clients, have learned how the frame can become the most succinct and powerful commentary the picture can have—something

that can be, by turns, a caption the picture carries to explain it, a laurel to crown it, or, not unusually, a kind of unjust sentence that the picture is forced to carry around on its shoulders forever.

Bailey is the most gifted observer I have ever met, the one man whom I would most trust to see a picture for itself, rather than for what's said about it, what's said beneath it on the wall label, or what's said around it by other observers. As the reader will discover, he sees for himself, and gives that simple phrase a renewed significance. His instrument of expression, eccentrically, is not the book nor the article nor the lecture, but a rectangle of wood and gilt and paint—a frame. Yet Bailey views the act of framing, and the act of looking at the frame after it's in place, not as a decorative act but a meaningful one, nothing less than a vindication of the purely visual, of seeing as a form of thought. To see him walk through a museum or gallery with his two hands placed at neat right angles, so that he can remove the given frame from his field of vision, in order to concentrate on the frame the picture really wants, is to be forced to look for yourself, too. In this book, he at last tries to teach what he sees, and how he sees it.

Bailey invites anecdotage—he is a private legend now gone public—and, since he has pitched this book in an intense, impersonal, educative key, I cannot resist just a couple of them. I first met Bailey when we brought him a Piranesi that my wife had inherited. It was an image of the Pantheon in Rome, at mid-day, full of dark Piranesian detail, and I had clear, precise, stubborn, and, as it turned out, extremely stupid ideas about the dark and impressively Romantic frame it needed. Bailey, a gentle bearded presence inside a Hawaiian shirt, smiled, and started looking—not talking but looking. If you look at this piece, he pointed out, and forget the loaded name "Piranesi," you see that it's really all about afternoons and sunlight and serenity. A single patch of sunlight (it was, of course, no more really than an empty patch on an aging piece of paper) radiated from the oculus at the top of the Pantheon, and that patch, that ray of sunlight, was the real center and secret of the print. The task for the framer, he went on, was to see if that light could regain its radiance for the viewer. After much thought, he chose a caramel-colored mat and a distressed-gold frame—and suddenly a Roman afternoon in the early nineteenth century came to life and to light. A wholly different, lulling side of Piranesi's genius was present, too, which I have ever after been conscious of in much of his other work: Piranesi is an artist of shadow *and* sunlight. I never look at that picture now without thinking about the difference between what we say about an artist's vision and what pictures show us about his eyes.

On another occasion, we brought him an almost monochromatic Japanese theater print; he found the moonlight in the background, and designed a silver mat and ivory frame to bring it out. (On other occasions, Bailey's genius has been touched with a dark wit: we once

brought him a photographic portrait of James Thurber stuffed into a cheap plexiglass box. He took it, took it away, brooded over it, like a monkey with a nut, and finally returned it—in a hand-made replica of the plexiglass box it had arrived in. I like that lesson too, on the serendipity of the seemingly casual choice. We overframe more often than we underframe—put too much around a picture to let us see the picture.)

I have come to look forward to a Bailey session not as a preliminary to getting a picture up on the wall, but as a lesson in looking. For Bailey, a frame is a record of thought: an announcement, the clearest one we possess, not simply of what makes the picture look good, but of how the possessor regards his picture—as a period piece, as bullion, or , rarely, as an act of thought made visible. I rarely walk through a museum now without a sense of indignation at the stupidity of the frames. Not simply their ugliness, though there is plenty of that, too, but their lack of insight into their own possessions, like a man who boasts of a trophy wife without ever looking her in the face to see her real fragility or strength. "Putting an edge around" is Bailey's favorite, modest, phrase for what he does, and if putting an edge around can be a way of getting at the picture's visual heart, it can also be a way of framing in the other sense—a way of saying what world, what context the picture really belongs to. A frame can announce a whole epoch.

In this, his first attempt to guide eyes that do not have the privilege of his presence, he gives readers the benefit of all this knowledge. Absorbing his almost wildly detailed readings of picture surfaces, what strikes me most is how succinctly he leads the viewer past mere detail toward the life-giving conflicts in the picture. His description, for instance, of the deliberately over-the-top frame designed by Ingres for his cool portrait of Madame Moitessier reminds us of how much the Second Empire was structured throughout by a tension between chilly Greek and hot Chinese form, between the Ingres line and the emperor's mustache. Talking about Whistler, Bailey forces us to see how the frames of Whistler's own invention constantly emphasize the shallow depth of the picture and extend the picture out into the wall in an embrace of decor that anticipates Matisse. Only Bailey would have noticed the way that, in a Whistler portrait, the frame's signature butterfly and the painting's butterfly connect the depicted image to the inside edge of the frame, pushing the picture flat and announcing its decorative purpose. This is "reading" a picture in the deepest sense: not for what puzzles it may contain, but for what lessons it points about a period and a painter. The close readings of picture surfaces in this book—in places, they go on for two or three paragraphs—are a shaming reminder of how shallowly we look, how casually we see.

And what I value in them, too, is that they are not merely inventories of visual incident but records of the play of forces in the picture, which a frame can enter, accent, or, more

often, deaden. More than anything else, Bailey believes in this play of forces: he reminds us that formalism, properly undertaken, is a preliminary to feeling. Bailey makes no claim to superior knowledge but the evidence of his own eyes, and he trusts that the act of looking implies everything else. Once, he had been given the job of framing van Gogh's *Starry Night* at the Museum of Modern Art, and day after day he tried to trace and track the play of forces in that strange and sublime picture in order to imagine its frame. Where is the center of the picture, he asked, over and over—what is its real center, its visual nucleus? He found it at last: a single worm-hole star, inverted rather than merely radiant, which sits exactly dead center in the picture, easy to overlook, like a beckoning tunnel. He turned to Vincent's letters, and came upon a passage—famous, though he didn't know it then—where Vincent writes that he sees the stars not as things in themselves but as signs of a kind of divine conveyance, railroads to a better world. That was Vincent's real vision, not radiance outward but an invitation inward—and, through the act of really looking in order to put an edge around, he had found the secret train track Vincent had set there, a train track to the stars.

I don't recall if the frame was ever made, but the picture's code had, for me, been broken. From Bailey's frames, which I treasure as I treasure the pictures inside them, I learn every day about how to see, and from his writing here I learn about all that looking can imply— that a frame can be like a superior detective, come to force the picture to confess its real intentions, saying, as detectives will: "Come out, come out! You're surrounded!"

THE STORY
OF THE
PICTURE FRAME

When we look at a framed painting on the wall of a museum, we rarely call the frame into question, treating it as a decorative element subordinate to what it encloses. In fact, the frame is the product of a rather complex series of aesthetic and practical decisions that affect in many ways how we see pictures. The pleasure of looking at a picture in relation to its frame is often neglected and seldom discussed. That pleasure has inspired this book, a personal survey of the achievements of frames and images as they have joined together in a dialogue of mutual enrichment. By looking at different types of images, we can begin to find a link between the visual world as we know it and the one perceived by our ancestors. In the process we will see the frame emerge as a useful pictorial device that has over time become a nearly constant presence in the experience of looking at pictures.

We do not know what motivated the earliest painters to depict animals on the walls of caves, but what we find especially puzzling today is the cave artists' apparent lack of concern for boundaries or composition. Animals were drawn on the rough, uneven rock walls frequently overlapping or abutting unrelated images, as if only the most recent drawing could be seen and the others had become invisible. Our contemporary bias makes us see these images as a dense area of transparent herds roaming over an empty field with no defined edge or

depth. There is no frame, no attempt to control the boundaries of the image. It was necessary for humans to grasp the concept of the figure-ground relationship before the idea of a frame could be developed.

We can trace the evolution of figure-ground by looking at three examples of early pottery. The first, a Chinese neolithic jar, has boldly contrasting dark and light lines, which force us to make a visual choice: which value, dark or light, is the dominant motif (figure) and which is background (ground). In the second example, an Iranian beaker, the painted silhouette of an antelope stands out against an empty background, a compelling, articulate figure, its solitary presence dramatized by the surrounding void. This ground is in turn surrounded and defined at its outer limits by a painted band that forms an authoritative rectangle of consistent width. The figure and the ground are thus effectively framed. This figure-ground relationship and the need to contain it are seen here in a pure, direct expression that is at the core of the concept and function of the frame.

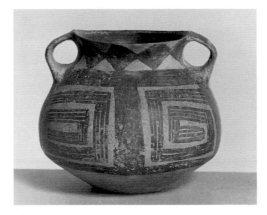

Chinese jar, Neolithic period

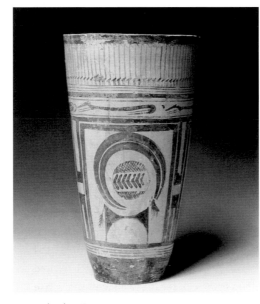

Iranian beaker, Susa, c. 4000 B.C.

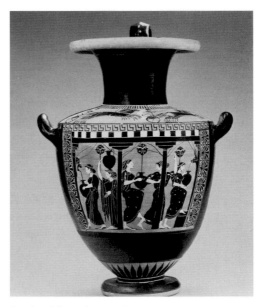

Greek red-figured vase, 5th century B.C.

With the flowering of Greek vase painting, the figure-ground concept was brought to an elaborate and sophisticated level. The frame in the vase illustrated here has taken on an architectural form separating the figural images into scenes, and the decorative motifs used to surround them are made up of a vocabulary of stylized forms from which frame-makers from the Renaissance onward would draw an endless array of motifs. These same motifs are alive today on frames made all over the world in contemporary variations or in reproductions of traditional models.

Another function of the frame can be seen in early forms of architecture. Viewed from the dark interior of a cave or primitive hut during daylight hours, the exterior landscape is revealed as an isolated fragment, "framed" by the opening, so it is not impossible that the notion of the frame arose at some very early point in our existence. Certainly, we can imagine the cave dweller's sense of comfort and security at the sight of the outside world visually controlled from within a safe refuge. Though vastly different in context, an arching allée or tunnel of dense shrubs within a large garden provides a similar sense of quiet and protection inside a cool, darkened space. Walking from one end of the enclosure to the other, the visitor gazes out through the approaching aperture at a meticulously selected slice of landscape.

Certain sacred sites are physical manifestations of the need to define our place on earth in relation to the heavens. An assertion of "down here" in opposition to "up there," these sites can be perceived as a three-dimensional equivalent of the figure-ground concept. Stonehenge may thus be viewed as an early frame. It was apparently intended, at least in part, to grant access to celestial events by locating them precisely for the viewer on earth. Evidence of this precision can be found in the annual midsummer sunrise over Heel Stone, among other solar settings and risings. Stonehenge is only one example of such structures—think of the sunlight framed deep inside Egyptian pyramids and Mayan temples—made to function as containers for various celestial phenomena, encapsulating the universe, however briefly.

Temples, tombs, shrines, memorials, and other cultural landmarks became more complex as engineering knowledge and expertise increased, as did the impulse to embellish or decorate the structures. Rectangular blocks became the preferred building form in most cultures, and exposed surfaces on both exterior and interior walls lent themselves admirably to painting and carving, as in the Minoan bull-leaping fresco from Crete. A simple way to set off the images and integrate them into the overall structure of the building was to surround them with borders of consistent width. Over time this form of encasement was decorated, and eventually elements of the architectural frame were incorporated into the picture frame as we know it today.

The actual use of a frame on a picture began with the painted icon early in the Christian era. The Old Testament forbade the veneration of images, but as early as the second century A.D., Christians—who were certainly familiar with the Roman portraiture tradition—worshiped images of holy figures painted

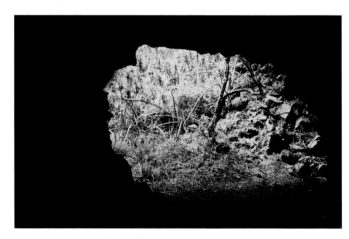

Cave entrance from the inside looking out

on relatively small wooden panels. Because icon veneration was at first a secret practice, covers were devised to make the icons portable while protecting the images from environmental damage and from discovery by nonbelievers. The central image was painted on a recessed surface carved into a flat wood support surrounded by high, narrow edges. This structure allowed hinged side panels, also painted, to close over the main image so that the painted surfaces could not touch and thereby abrade one another. A single strip of wood at the top protected the wings when closed and formed a secure traveling unit.

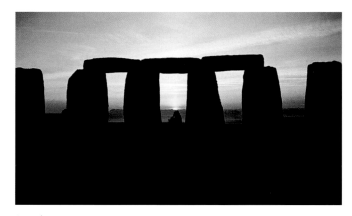

Stonehenge at sunset

Later, icons were displayed in churches, hung on panels, painted in apses, or used as covers for altar gospels (see p. 20). These images were often elaborately framed, usually in gold, and decorated with precious stones; the frame also provided an area for inscriptions or supplementary images of figures or scenes related to the central portrait. Icon makers also fashioned two- or three-piece frames, diptychs or triptychs, which could be packed up for storage or transport and could also be opened to support the image on an altar for worship.

As the Christian church prospered, altarpieces were commissioned for specific sites and gradually became large and elaborate, reflecting not only the spiritual values of the community but also the wealth of the church and of its patrons. Simple panels with pointed tops and moldings attached to the edges gradually replaced the traditional rectangular format, and moldings became wider and took on decorative characteristics of their own, thanks to the introduction of rich materials and supplemental images. Stand-alone altarpieces, often consisting of several pieces and no longer portable, mimicked the Gothic church facade by appropriating its intricate architectural details, such as arches, finials, open tracery, and columns at the sides to provide grandeur.

The Gothic-style altarpiece was gradually transformed during the fifteenth century as it acquired classical design elements derived from ancient Greek and Roman temples that were being uncovered in Italy. The Gothic arch lost its pointed peak and became

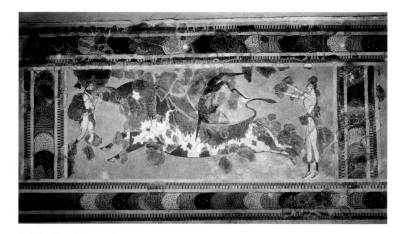

Bull leaping, Minoan fresco, c. 1500 B.C.

rounded, although during the transitional period, the two styles were sometimes found in the same altarpiece (see Gentile, p. 23). The outcome of this stylistic transformation was the Renaissance tabernacle frame (see Glossary), which was applied not only to altarpieces but also to actual tabernacles (boxes holding consecrated elements of the Eucharist), reliquaries, and even tombs. This type of frame no longer resembled an altarpiece so much as the facade of a classical temple as seen through Renaissance eyes. A rectangular unit was frequently crowned with a full triangular pediment filled with ornamentation, a "broken" pediment recalling ancient ruins, or a rounded arch containing a separate painting or lunette. The tabernacle frame also acquired a new element—the antependium—which appears below the horizontal base supporting the "temple" unit. This triangular area, which serves as a visual counterpart to the pediment above, often contains the liveliest decoration on the frame—such as shields, coats of arms, inscriptions on volutes or scrolls, and the ubiquitous acanthus leaves—perhaps because its position closer to the earth made it fair game for imagery that would not be appropriate above a religious scene.

During the Renaissance, artists also produced religious pictures for private veneration outside the public church. These pictures were placed in personal rooms of palaces or in family chapels. The nobility, wealthy and powerful, commissioned portraits of themselves and of family members as proclamations of self-importance and attempts at immortality. Influential families such as the Medici began to commission other secular paintings and amassed large collections. Displayed in grand halls, accessible to the community on special occasions, these collections were precursors to our public museums. The paintings were set in simple cassetta frames (see Glossary), all finished in the same manner to unify the presentation. Display became an increasing concern, and the art of picture framing thrived not only in Italy but throughout the rest of Europe. Pattern books showing the construction and decoration of frames were published in urban centers and disseminated to craft shops, where designers eagerly awaited the latest styles. Following trade routes, these new designs found their way to Russia, the Near East, and even South America.

These books contained a multitude of engraved motifs, organized and classified into various categories, but they seldom illustrated an entire frame around a work of art; asymmetrical mirror frames were often the only items shown in full. It was not uncommon for painters to design segments or corners of the frame for a specific painting, especially when the painting was intended for a particular location, and the artisan would be instructed to complete the frame based on that design. Artists' sketchbooks occasionally include studies of frames and images together, but these are rare and usually quickly drawn. This remarkable sketch by Rembrandt is a real find: it clearly indicates that his large painting *The Sermon of John the Baptist* was to have an architectural housing of considerable substance, a wall installation with features adapted from the Renaissance tabernacle frame. Of special interest is the expansive arch, which curves and widens gently from the narrow center to the pillars at each side. This "un-squaring" of the top of the frame is a device used to open up the sky in a landscape, an allusion to the power that emanates from heaven, a device that Greg O'Halloran uses in his 1989 painting *Tsunami* (see p. 77).

The solid base that Rembrandt shows here indicates that the final frame will provide a visual support for the crowd of figures. He has drawn a wide beveled edge along the bottom of the painting with simple parallel strokes

Rembrandt van Rijn, Sketch for *The Sermon of John the Baptist*, c. 1635

perpendicular to the edge, much like those used by van Gogh for his still life (p. 119) to serve the same purpose of easing the viewer's access into the painting. The astounding part of Rembrandt's sketch, however, is the sense of scale; small as the drawing is, we know we are in the presence of a large, powerful work of art, which is why the artist wanted us (or his patron) to see it in the full frame.

Another function of the frame may be to impart a particular set of design attributes, historical references, and social relevance to the picture. In the Renaissance or the Baroque era, for example, this mission was accomplished with relative ease within the prevailing culture. Painter, sculptor, architect, and artisan shared a similar aesthetic, often performing work outside their stated discipline, usually under the supervision of a master or patron who would oversee the design and production of many diverse elements within a single project. The picture frames that resulted were conceived in harmony with all the other elements of the project, from a salt cellar to chairs to a palace garden. Museum period rooms, in which works of art are displayed together in furnished interiors, are intended to evoke the original context in which one can see the design unity of an era, where frames and paintings function as one of many integrated elements in a composed and orderly environment.

Eventually, however, the notion of a predominant style orchestrated by a single aesthetic sensibility disintegrated and fragmented into many art movements that explored a multitude of aesthetic concerns. The resulting eclecticism affected frames just as it influenced other forms of the decorative arts. If we visit the painting galleries of any major museum with the intention of looking at pictures within their frames as units of visual pleasure, we quickly come up against a series of awkward situations.

Three views of the same painting, a 1610 portrait of William Shakespeare by John Taylor, which has been in London's National Portrait Gallery since 1856, reveal how a picture may be altered significantly by a change in frame style. This comparison reminds us how our perception of works on display is affected by circumstances, whether they be the result of chance or of a particular curatorial taste. The portrait, although skillfully rendered, is a straightforward academic painting, which appears undistinguished, one of many produced during the early seventeenth century. The addition in 1864 of an elaborate gold frame with Neoclassical motifs at the corners added distinction to the presentation but called more attention to itself than to the painting, which struggles to be noticed. The tortoiseshell frame at the right was installed in 1983; although it is not of the same period as the portrait, it enhances the scale of the picture and complements the colors in the image rather than detracting from them.

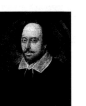 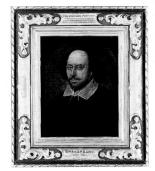 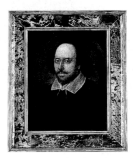

Three views of John Taylor's portrait of William Shakespeare, c. 1610

In the seventeenth century Louis XIV established the Salon, an annual exhibition organized by the French Academy to exhibit the work of its members in a manner that was eventually adopted by official art academies throughout Europe. As artists vied for attention from patrons and members of the public, salon walls became increasingly crowded with pictures hung floor to ceiling and corner to corner. This cheek-by-jowl approach encouraged artists to choose wide frames to keep the competition at bay and to enable the viewer to focus on their own work. By the nineteenth century newspaper cartoonists as well as critics made fun of the outsized frames and the "wallpaper approach" to hanging works of art. But the salon style was fully entrenched (and in fact survives today in some institutions), and despite jeering from the press, it was too late to halt the onslaught of massive frames.

Gold finishes were mandated by the academies, but as the size of the frames grew, the cost of expensive gilding became prohibitive and artists turned to cheap substitutes, which usually resulted in an overbearing, gaudy surface. Gertrude Stein summed up the feelings of many: "The Louvre at first was only gold frames to me gold frames which were rather glorious, and looking out of the window of the Louvre with the gold frames being all gold behind within was very glorious. . . . somehow there with the gold frames and all, there was an elegance about it all, that did not please me, but that I could not refuse, and in a way it destroyed paintings for me."[1]

Of all the functions of a frame, the most significant is that of mediator between the viewer and the painting, both physically and aesthetically. On the practical side, an effective frame reconciles the world of the viewer to the world of the painting in both form and scale. If the frame is too large or its decoration too prominent, it behaves like a bullying neighbor with a shotgun: it can overwhelm and intimidate the painting, making it seem feeble and diminished. If, on the other hand, a frame is skimpy in width and dull in ornament, the painting will suffer from a lack of visual support; its impact and structure will be weakened because the frame is unable to keep the image from being dispersed into the room or gallery space. As mediator, the frame must succeed in a challenging

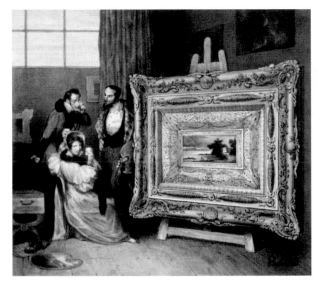

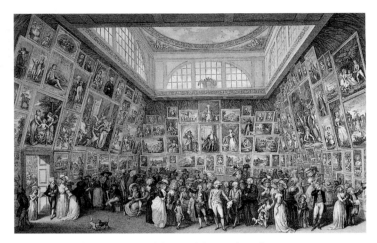

Bourdes, *"C'est un morceau capital, il fera le plus effet au salon,"* (It's a capital piece, it will have a great effect on the salon), 19th-century lithograph

P. A. Martini, after Ramberg, *Exhibition of the Royal Academy,* 1787 engraving after painting

twofold role; it must invite us into the painting and prevent us from escaping its bounds once inside. The design must effect a transition from the existing physical location, usually a wall in a room or a gallery, into the illusionistic realm of the painting. This should occur graciously and imperceptibly. The frame should also prepare the eye and mind of the viewer to accept and embrace the domain of the painting on its own terms. Once the viewer has entered the painting, the frame must allow the eye to wander freely within the confines of the painting's edge but prevent it from straying beyond the edge of the image.

The Spanish philosopher José Ortega y Gasset, in his essay "Meditations on the Frame,"[2] brilliantly ruminates on the idea of this under-discussed subject. He writes that if you reflect on the paintings you know best, you will probably not be able to recall the frames they have been set in. I hope that this book, by calling attention to the interplay between frames and paintings, will increase your enjoyment of these intriguing alliances.

1. Gertrude Stein, *Lectures in America* (New York: Random House, 1935), p. 70.

2. "Meditacion del Marco," in *Obras de José Ortega y Gasset*, 3rd ed. (Madrid: Espasa-Calpe, 1943), pp. 369–75.

1

THE FRAME AS ALTARPIECE

For a variety of reasons, many artists since the Middle Ages have returned to one of the earliest Western frame concepts, the altarpiece. This form developed even before the emergence of Christian church architecture from the tradition of icon painting, for which frames were made to house and protect sacred images. As church structures became spiritual and communal centers, artists worked with architects and artisans to create increasingly elaborate framed works. What became known as the tabernacle frame is now such a familiar fixture that artists today often exploit the form for its subliminal references, even without a religious intent. We now find these same tabernacle frames—authentic, old or recent copies, or modern derivations—in private collections and museums, where they surround portraits and secular scenes, as well as religious ones, lending an aura of importance to the work within.

This splendid gospel cover looks to us like an intricately framed portrait, and indeed it can be viewed for our purposes as a significant precursor not only to the altarpiece but also to traditional frame forms that are still in use today. Like the icon format on which this cover design is based, the central figure of Michael, although fashioned from gold rather than painted on a flat panel, is presented as an image to be venerated, surrounded with carefully delineated frames that define and emphasize the archangel's central role and segregate the lesser portraits into appropriate positions and sizes, presumably reflecting church hierarchy. This way of presenting religious imagery was incorporated into the design of medieval and Renaissance altarpieces, where it was subsequently integrated into an architectural framework and became what we now call a tabernacle frame. The decorative Byzantine elements on this cover, particularly the circular portraits and the liberal use of gold, were eventually adopted to enrich frames for religious as well as secular paintings (see Michelangelo, p. 45).

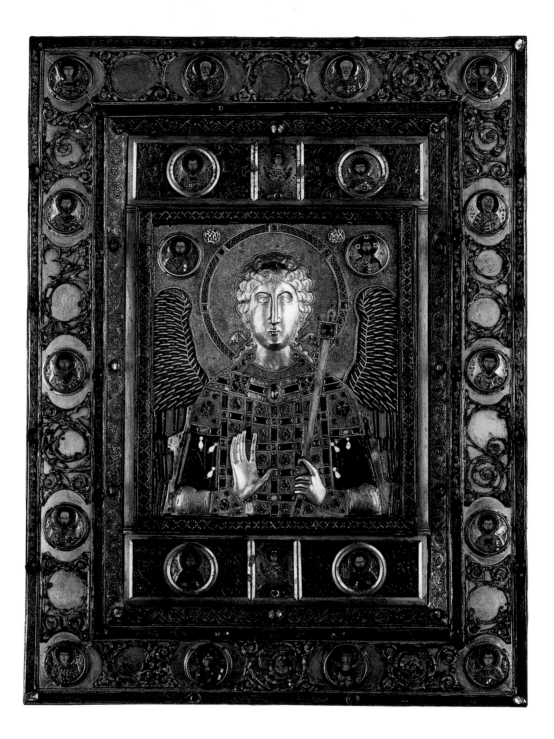

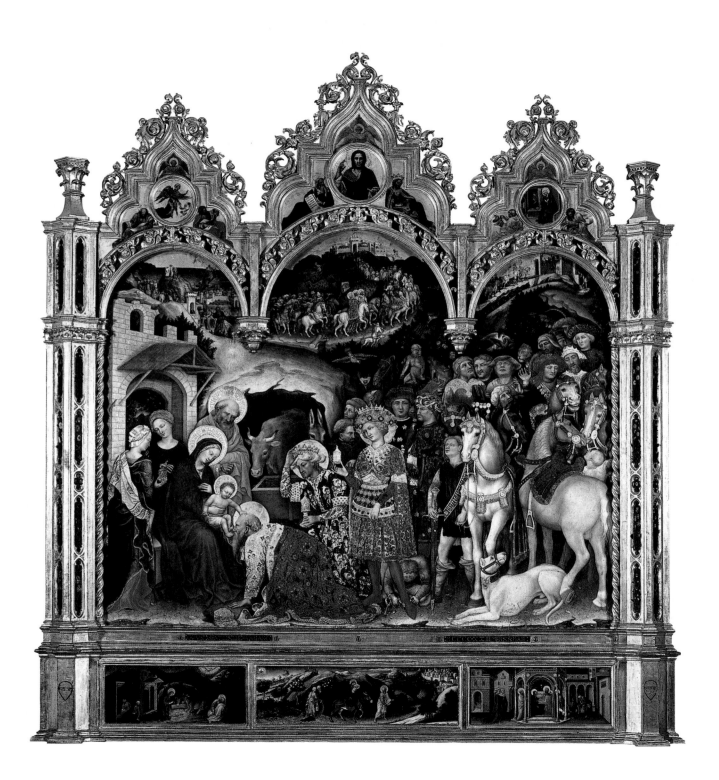

For our purposes, the most interesting aspect of this magnificent altarpiece is not the beautifully painted image of the Adoration of the Magi or the three flamboyant Gothic spires or the three-panel narrative of Mary and Joseph's journey to Bethlehem below. All of these are traditional elements in Renaissance altarpieces. What is unusual here is that this work represents a significant development in the history of Western framing: the altarpiece was made in two separate pieces: panel and frame. Until this time, altarpieces were constructed as a single unit, but here the two elements were made independently, with the stand-alone frame able to enclose and support the painting, which is on joined panels of wood.

The overall frame is an elaborate version of a traditional triptych except that the two columns originally needed to support the central arch have been removed, because the artist has used a cradle of bars across the back of the painting to support it and prevent it from cracking. The absence of columns allowed the painter to design a large single image nearly one hundred square feet in area without any architectural impediments. Although we are aware of and perhaps uncomfortable with the unsupported central arch, Gentile's skills as a designer and painter diverts our attention from this awkwardness by engaging us totally in the painting. This incongruity would soon be rectified as the Renaissance artists abandoned the Gothic style and concentrated on adapting classical motifs from ancient Greece and Rome. Soon the rounded arch would comfortably enclose wide spaces supported only at the sides with elegant columns (see Bellini, p. 24). The use of classical forms became popular so quickly that many Gothic altar frames, even those recently made, were completely reworked in the new style.

Within the three Gothic spires are circular frames (tondos) that contain portrayals of God the Father, the archangel Gabriel, and the Virgin, a traditional Byzantine format that would be retained well into the High Renaissance (see p. 45). The simple circular frames and the thin convex molding of the three tondos attract the eye by countering the flamboyant tracery of each spire. Placed directly above the arches, the tondos act as exclamation points calling attention to the three subject areas below, which Gentile has skillfully woven into a unified scene: the manger with the Holy Family at the left, the three kings in the center, and the group of grooms and horses on the right.

Along the base of the altarpiece (predella) are three horizontal, rectangular, framed units whose width corresponds to the arches above. When read from left to right like a story board, the images depict the stages in Mary and Joseph's journey to Bethlehem. The two vertical frame bars that separate the images are raised moldings, which clearly differentiate the panels but encourage our eye to move on to the next image.

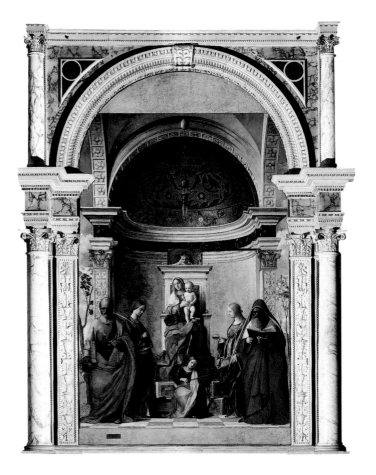

Albrecht Dürer, visiting Venice in 1506, wrote to a friend about the artist Giovanni Bellini: "Though he is old, he is still the best in painting." Dürer would have seen in Venice a number of recent works by Bellini, including this painting, one of a group of panels Bellini made for the church of San Zaccaria in Venice in 1505, when he was at the peak of his abilities. This remarkable painting epitomizes the High Renaissance union of frame and picture. The artist has devised a painted architectural setting that corresponds perfectly with the architecture of the church that surrounds it. It is a brilliant example of the tabernacle frame tradition in which architectural elements from classical temples were incorporated into the altarpiece structure to create a frame for a venerated image.

The figures stand within a painted space that appears to be an aisle in front of an apse, which is framed at the side by two decorated Corinthian pilasters that echo the actual pilasters on the church wall. The wings of the aisle are missing, and we see instead a bit of landscape at each side, which would not be possible in an enclosed church setting. Bellini's skill is such, however, that the intrusion of landscape into this interior does little to dispel the sense that this scene is taking place within the real church.

The artist has used several devices to help establish this illusion, the most effective of which is allowing the actual cornices supporting the arch to overlap the painting at the right and left. As a result, the two painted vertical arches propel us into the painted room and convince us that the figures are securely placed in a solid architectural setting. The cornice of the painted throne again echoes the architectural forms of the church, firmly securing the harmony of the framework that surrounds the central point of interest: the Madonna and Child. The figures are arranged in perfectly balanced symmetry, which is subtly enlivened by the S-curve of the Madonna's pose, another device to focus attention on the Christ Child.

Although the panel as a whole is a brilliant demonstration of the artist's skill, Bellini's intention seems not to have been to dazzle, so much as to incorporate the viewer into the scene by copying various elements of the actual architectural framework to create a convincing extension of the church.

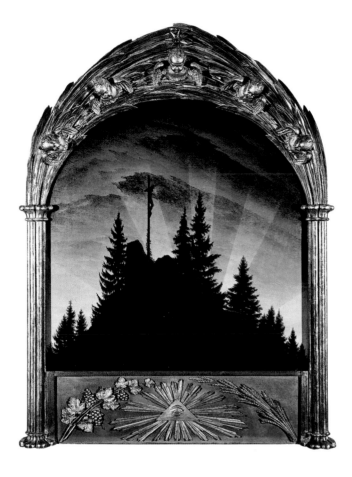

Friedrich's painting could easily be categorized as just another Romantic view of a landscape at sunset if it were not for the extraordinary frame that the artist conceived to manipulate the way we perceive the work. Designed in the shape of a Gothic arch, the frame is rich in symbols and motifs reminiscent of medieval religious art. An Eye of God, surrounded by rays of light, dominates the base panel; flanking this, on left and right, are a sheaf of wheat and a grapevine, references to the Eucharist. These symbols are carved in relief, covered with luminous gold leaf, and set against a painted background of warm earth tones. On the sides of the frame, Gothic columns culminate in palm fronds that arch up elegantly to the top, an allusion to Palm Sunday and Christ's triumphal entrance into Jerusalem before his Crucifixion. The fronds are populated with five angels carved in the round, which lean outward as they peer down into the painting.

Because of our low vantage point, the first thing we see is the silhouetted bare rock of the mountaintop, backlit by a dramatic sunset, complete with heavenly beams of light and opaque gray clouds tinted with blood red. This is a moody, somber scene made all the more austere by the opulence of its frame. If one looks quickly at the picture, however, it is easy to overlook the most important element—a cross, on the far side of the mountaintop nearly obscured by the fir trees. The cross faces away from us at such an oblique angle that it looks like a branchless tree trunk among the firs. The focused gaze of the five angels along the top of the picture frame keeps us from missing the point. The angels make sure that we do not leave without bearing witness to the Crucifixion, the quintessential Christian symbol. Through both its form and its symbols, the frame is our means of access into the full content of this painting, as it transforms a romantic landscape into a powerful and evocative allegory.

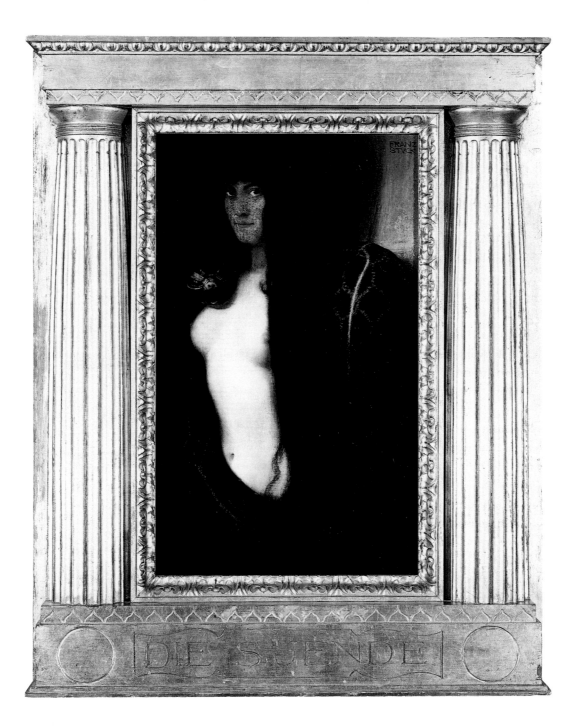

Like many artists of this period, including his Viennese contemporary Gustav Klimt, Franz von Stück exercised numerous artistic talents, serving as architect, designer, and stylist in addition to painter. Von Stück's own house and studio were elaborately decorated, even by the opulent standards of the day, with an interior inspired by classical Greece that served as a setting for his paintings, which were displayed on easels and shelves, each embellished with unique frames designed by the artist. Within this space, von Stück erected a complex personal altar near a window and decorated it with gold and mosaic. *Sin*, his masterwork, was at its pinnacle.

Saturated with overtones of morality as well as eroticism, *Sin* depicts a partially nude woman, who, seen from the waist up, her face dramatically hidden in shadow, is embraced by a large snake, whose head—hideously combining features of reptile, swine, and human being—looks directly at us over her right shoulder. Surrounding this dark portrait is a gilded architectural frame inspired by a classical Greek Doric portal, whose purity sets up a dramatic contrast with the subject of the painting. The frame suggests a temple structure intended to enclose an object of worship, but the woman within represents powerful sexuality and hedonistic pleasure, and the serpent lends an alarming aspect of evil.

The artist has set up this conflict of frame and image to force the viewer to confront eroticism. At the time *Sin* was painted (1893), European society was obsessed with sexuality, which was often presented in disguise to make it acceptable to those who considered it evil. Many academic artists painted images of sexual desire disguised as themes of classical mythology, but this kind of deception was viewed as morally reprehensible by avant-garde artists and intellectuals at the end of the Victorian era. Von Stück brilliantly expressed this collision of values in *Sin*, which was so popular that numerous replicas were made under his supervision to fulfill public demand. The woman in the painting seductively beckons us to draw near, but the challenging glare of the serpent forces us to stand back and acknowledge our own erotic impulse.

Photograph of the artist's studio

When entering a certain windowless alcove in the Philadelphia Museum of Art, we see at the left, between the gallery walls, an arched brick portico that surrounds a solid, intricately constructed, and apparently old wood-paneled door. It is a formidable barrier, closed by a crossbar nailed on with heavy spikes and is hardly suggestive of a frame. But a frame it is—for the last major work of Marcel Duchamp, one of the most innovative artists of the twentieth century. *Étant Donnés*, a bizarre and disturbing three-dimensional construction, was completed in 1966, more than fifty years after *Nude Descending a Staircase No. 2*.

A closer look at the door reveals two small, ragged holes in the worm-eaten wood placed at eye level and separated by the width of a nose. Most people are compelled to look through holes like these, but the jagged shapes of the openings have an off-putting quality that does not invite a casual glance. Do we really want to know what is going on behind this odd and foreboding barrier? Duchamp is up to one of his usual intellectual gambits, enticing and repelling us at the same time, toying with both our emotions and our values. Is this art or mischief, or both? Should we succumb to our voyeuristic impulse and fall prey to base instincts, even lowering our moral standards along the way? Of course. An inch or so behind the door is a large, irregular opening in another brick wall that frames a diorama with the partial view of a nude woman in the foreground, her raised

left hand holding a lighted lantern. At this point we realize that a reversal has taken place. At first, we were outside looking in, and now Duchamp has deceived us into feeling enclosed in a room, from which we are now looking out. Although we see blue sky, trees, rocks, a sparkling waterfall, and a lake covered with mist, the bucolic character of the scene is nullified by the nude, whose body is limp as if she had fallen from a great height. Luxuriant blond tresses cover her face, contrasting dramatically with her shaved pubic hair. Her vagina is agape and distorted. What we have found behind the closed door is raw sexuality, but what else did we expect? Isn't this what we secretly hoped to see? We experience at once a rush of emotion and a sense of guilt.

As we withdraw from the scene, we are outside the frame wall again. Relieved by its presence, we are pleased to have the wall function as a physical barrier to the scene we have witnessed and hopeful that it can protect us from ourselves, an ironic, irreverent switch on the altarpiece tradition. For this is, in fact, a primitive version of a tabernacle frame consisting as it does of a classically proportioned arch and columns although constructed of brick and lacking the ornamental details of its predecessors.

2

THE FRAME AS WINDOW

In the introduction, we discussed how Western framing devices evolved. The cave opening (seen from within the cave) may indeed have been the first window, even if our ancient ancestors were quite unaware of the concept. It is easy for us, however, to see the cave opening as an undeveloped window, since we usually envision a pane of protective glass set in a frame or a sash that can be opened or closed. We tend to treat our fixed windows as frames, so that they define views of what is particularly pleasing on the outside. The reverse can also be true, as when a commercial window facade is designed for looking into specially designed displays or areas.

It does not take much imagination for us to see the picture frame as the window sash for art. A literal example of this is Larry Rivers's portrait of Jim Dine (see pp. 82–83), in which the artist has created a visual pun that plays on the venerable history of the frame and the role it has played in the way we look at art. One of the major functions of a good picture frame and a good window is that it serves as a transition between the world we stand in and the world represented by the picture. As such, the frame allows us to step from one world into the other and helps us maintain our focus as we relax and enter the world of the painting.

Once we are safely within that realm, the frame's role shifts to one of a security agent ensuring that we can spend all the time we want actively engaged with the work of art. The work of art itself has always been considered a kind of window into the artist's mind and imagination. Huge warehouse installations, giant sculptures, and paintings the size of buildings engulf the viewer and put us inside the work, forcing us to adopt the artist's vision. Smaller works usually require a mediator, a window or door into which we are invited to step and through which we must allow our own imaginations to enter. That entryway is the frame of the picture.

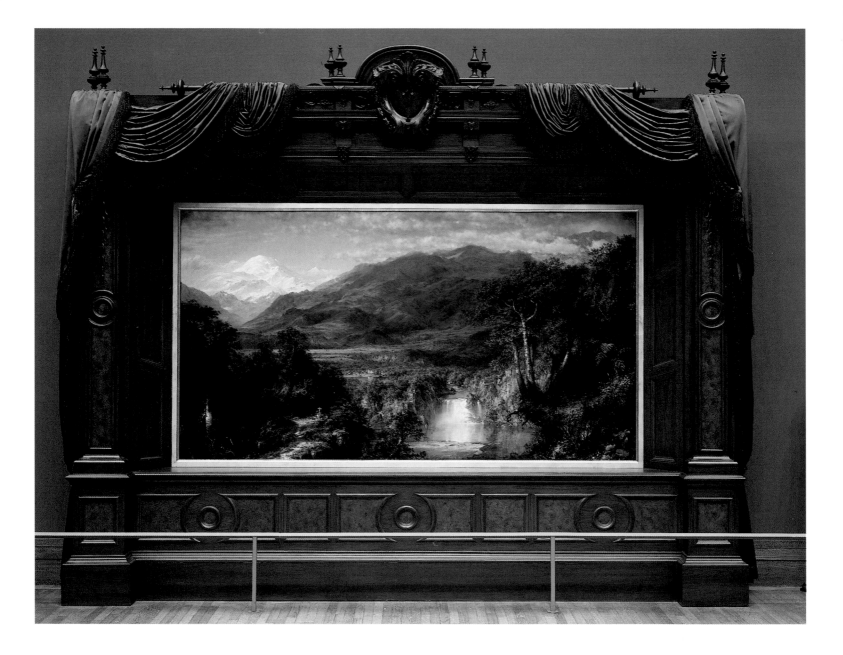

In 1989 the National Gallery of Art in Washington D.C. exhibited Church's masterpiece *The Heart of the Andes*, for which the museum built a facsimile of its original frame, an imposing tabernacle frame that had been removed nearly a century earlier. The artist's intention in designing that impressive frame reveals a great deal about the New York art world in the mid-nineteenth century, the era of P. T. Barnum's American Museum, where a little natural history was presented with a lot of theatrical hokum. Church was clearly inspired by the so-called Great Work shows that were mounted in London and Paris during the 1850s as an alternative to the constraints and competitive atmosphere of the stuffy official salon exhibitions.

A Great Work exhibit, which was a social as well as an artistic event, involved the elaborate presentation of a single monumental landscape painting by an artist sufficiently well established to draw crowds. A special hall was rented and fitted with special lighting designed to create the effect of sunlight emanating from within the featured landscape. Potted plants were placed around the painting, which was usually presented in a suitably important frame. Promoters were hired, advertisements were placed in newspapers, posters were distributed—all part of a full-fledged publicity campaign. Church's broadsides blanketed the city, encouraging people to bring binoculars or opera glasses to view the astounding details of foreign flora and fauna, skillfully painted with scientific accuracy. Admission was charged for viewing, and engraved reproductions were sold for display in the home, the office, or public spaces. The entire proposition, in addition to being lucrative, brought widespread attention to the work and increased the likelihood that it would find a generous buyer.

The Heart of the Andes, a complex distillation of Church's two South American journeys, is huge—five and one-half feet high and a fraction under ten feet wide—but the free-standing black walnut encasement, which is in many respects more like an altarpiece than a picture frame, is even more monumental: about thirteen feet high and fourteen feet wide. The artist's intention was to create a Renaissance-revival window that would persuade the viewer he or she was looking into a real landscape rather than a painted one. The painting sits at the back of a kind of sill or shelf, its horizon line fixed halfway between the top and bottom of the frame, at the eye level of an average adult viewer. The structure and position of the coffers at the top and sides of the frame create a forced perspective that seems to push the painting farther away from the viewer than it really is.

Church hired an English designer familiar with the Great Work installations in London to install the painting and its frame in the newly built Tenth Street Studio Building underneath a glass-roofed atrium. Opening night was a grand social event, and many of those who showed up remembered it as a cultural high point for decades. During the three weeks that followed, attendance averaged more than five hundred visitors a day, each paying twenty-five cents for the privilege. This phenomenon was just the beginning of an extraordinary journey that the ensemble would make over the next few years, which made for Church not only a fortune but also a reputation he was never able to live up to. The facsimile frame, now on permanent view at the Metropolitan Museum of Art in New York, affords us an opportunity to savor a brief period in art history when the grandeur of painting was met in equal measure by the extravagance of the frame.

The impact of Japanese art on Western Europe has been called "the Great Wave," after a famous woodblock print by Hokusai, an appropriate image for the immediate and dramatic effect that began in 1855, when Commodore Perry reopened commerce with Japan after an embargo of two hundred years. The pictorial idioms created by Japanese artists were taken up with great enthusiasm by avant-garde European artists who found in ukiyo-e prints, for example, a fresh approach to traditional methods of conveying perspective, color, form, space, and depth.

Vincent van Gogh was delighted to find works of art that spoke to his own visual explorations, and he became an early admirer and zealous champion of these prints. He and his art-dealer brother, Theo, organized an exhibition of Japanese woodcuts at the Café Le Tambourin in Paris

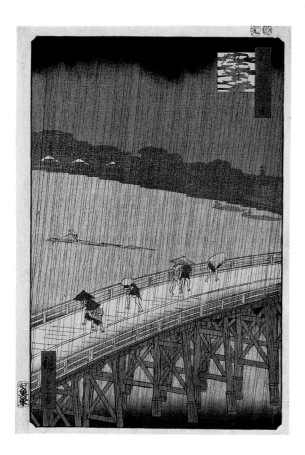

so that other artists and collectors could be exposed to this work. "Whatever one says, even the most common [Japanese] prints colored in flat wash are admirable to me for the same reason as Rubens and Veronese."[1]

In addition to promoting these Japanese prints among his contemporaries, van Gogh also examined them in his studio and made several paintings based on prints by Hiroshige, a kindred artistic spirit and creator of landscapes. One of these paintings, *Japonaiserie: The Bridge in the Rain*, is shown here with its inspiration, Andō Hiroshige's *Sudden Shower*. In making this copy, van Gogh took the opportunity to explore the similarities and differences between his ideas and those of the Japanese landscape master.

He captured most of Hiroshige's effects, translating the action of the scene—people rushing across a bridge in a sudden downpour—into his own style, in which he outlined areas and filled them with color. He was already familiar with the bird's-eye viewpoint, having employed it in many of his landscapes painted in the south of France. The most striking difference between the two pictures is the emphasis van Gogh placed on his wide, brightly colored border, which he has enriched with elements adapted from the inscriptions on the Japanese print, as well as an interpretation of the *kakemono-e*, an elaborate brocade used to mount Japanese painted hanging scrolls.

His painted frame, however, is a complete departure from the Hiroshige print, which has only the typical Japanese black line around the image, with a small quarter-circle notch at each corner. Apparently van Gogh could not abandon the Western concept of the frame when it came to treating the edge of his own image. Frames were a subject of deep concern to this artist; he often worried about finding

the proper frame for his paintings, and his letters to Theo abound with comments on suitable framing (see p. 119). Fully aware of the simple white or colored frames of the Impressionists and Post-Impressionists, van Gogh produced a number of painted surrounds for his pictures, either on a separate wooden frame or directly on the canvas.

In this effort to remain true to the Japanese aesthetic, while at the same time satisfying the Western desire for a zone of transition, he painted a vermillion line at the simulated frame edge, a substitute for the black line of the woodcut, and he surrounded this line with a contrasting bright green border of equal width, consistent with the Post-Impressionist device of using complementary colors at the framing edge. He then painted, directly on the green border, calligraphic characters adapted from inscriptions on the print, as well as his own versions of the red-and-yellow cartouches in which they appear.

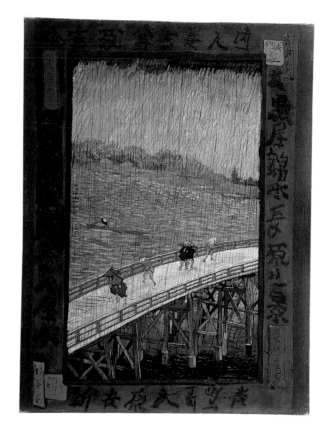

The Japanese use of calligraphy-filled cartouches directly on the picture is both a traditional design element and a means of augmenting the scene by providing relevant inscriptions, poems, or signatures. To a Western eye, these seem intrusive, as if they were pasted on the picture at random, but the Japanese do not regard them as impediments to viewing the image, reading them much as we read an artist's signature. To the Japanese eye, these cartouches appear to sit in front of the picture plane, establishing a boundary between the world of the viewer and the world of the picture, thus creating an illusion of depth. As such, they serve the same function as a conventional Western frame—keeping the two worlds distinct while at the same time making a bridge between them. However, like other Europeans conditioned to Renaissance perspective, van Gogh may have felt that the cartouches did not belong on the image itself, and he found it necessary to place them outside the picture on the painted green border. Interestingly, van Gogh also doubled the number of cartouches and placed the pairs opposite each other on the diagonal, balancing the composition rather than retaining Hiroshige's asymmetry.

In spite of this visual emphasis on the frame, van Gogh's landscape scene is not diminished any more than it is in Hiroshige's picture, but when the two are compared, it is clear that in spite of his efforts to make a Japanese picture, van Gogh has produced a Western landscape with a Japanese setting.

1. Vincent van Gogh, Letter to Theo van Gogh, no. 561, c. November 12, 1888, *The Complete Letters of Vincent van Gogh* (Boston: Little, Brown, 1958), pp. 102–4.

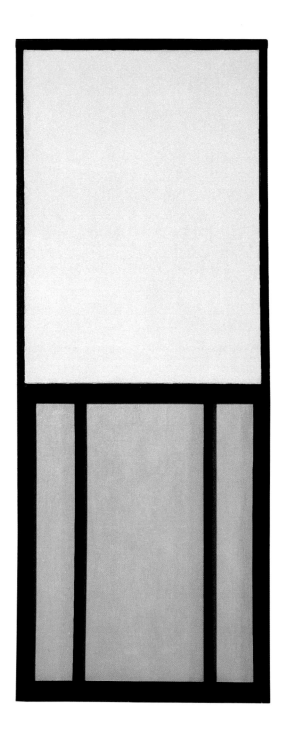

Window, at the Museum of Modern Art, Paris, photographed by the artist, 1949

Ellsworth Kelly works from direct observation, but his art involves a distilling process that in the end virtually eliminates any identification of the source. One of his first mature works and an example of this reductive process is *Window, Museum of Modern Art, Paris*, made when Kelly was studying in France. The piece shows a young artist's fresh approach to a common and much-used architectural and pictorial device—the window frame.

Windows have fascinated artists since the early Renaissance because of their usefulness in delineating one's view of a scene. In this relief sculpture, however, Kelly has not used that traditional approach toward the window as a divider between the inside and outside of the works of art; rather, he was simply impressed by the window as a structural object in itself.

After studying art for two years at the School of the Museum of Fine Arts in Boston on the G. I. Bill, Kelly returned to France, where he had been briefly stationed outside Paris during World War II, and enrolled in the École des Beaux Arts, where he stayed from 1948 to 1954. This effectively removed him from the art scene in America, where the critically acclaimed work was either purely formal or a distinctly personal expression. Kelly found the atmosphere in France more to his liking, because artists were taken seriously, regardless of style, and treated as viable and productive members of society. He felt free to pursue his inclination toward an art that was both precise and ostensibly impersonal, based on observation.

Part of Kelly's regimen in France was visiting museums and famous monuments; at the Museum of Modern Art he was struck by the tall windows on the main floor, which affected him more than the art on exhibition. Kelly had already made abstract drawings of window mullions and frames, exploring negative and positive forms, and had created simple reliefs of these motifs using string on paper. After visiting the museum, Kelly made drawings of one of the windows he had seen, adjusting the proportions without distorting the initial impression of their distinctive structural beauty. He then proceeded to make a relief object to represent the window. He joined two stretched canvas panels (one painted white, the other gray) with black wood framing strips, reversing the bottom gray panel to be recessed with the black stretcher bars facing out. Two more vertical black strips were added on the bottom section over the gray canvas to represent the center window mullions. The whole image is a unit and as such cannot easily be broken down into formal compositional elements. The unity of the piece is its meaning. The art is as much about the process of its fabrication, systematic and painstaking, as it is about the source.

Kelly's lack of interest in using the stylistic devices associated with artistic freedom and the expressive sensibility of the gesture, as epitomized in Abstract Expressionism, anticipate Frank Stella's early paintings (see p. 126) and Jasper Johns's pictures of targets and the American flag. As a work of art, *Window* epitomizes the subject, eliminating its functional and narrative associations without denying its connection to visible reality. It is a seminal work in which Kelly flaunts his detachment from the traditional concept of the picture frame by incorporating the frame into the content.

Rainbow, 1983–85

Hodgkin takes a refreshingly original attitude toward the relationship of frame and picture. He uses simple and fairly traditional moldings, often of ample size and scale, to surround his colorful abstractions; one gets the impression that the artist inserted a blank canvas into a molding before he began to paint the "picture" within it. When the painted image is allowed to extend beyond the confines of its frame, the artist incorporates the three-dimensional molding itself into the composition, establishing a dramatic tension between real and illusory space. Hodgkin creates an effect similar to that experienced in a theater when actors are seen through a scrim upon which images are projected. Here, as in the theater, we must allow two discrete experiences to be absorbed at once.

Hodgkin manipulates these components in *Rainbow* so that we see, simultaneously, a floating, openwork screen and a solidly formed frame. Each element seems to deny the other's existence, and this arouses our curiosity: What exactly is going on here? A curtain of luminous sequinlike shapes appears to float in front of the frame on which it is painted, each shape suspended and held together by some mysterious magnetic force. The improvisational character of the brushstrokes makes the shapes seem as if they are moving in unison, passing over the framed image. The vivid black and green of the frame molding contrast dramatically with the suspended red blobs, which convincingly float forward off the surface on which they are painted.

Although highly abstracted, the rainbow that is the subject of the image within the frame hovers in a post-rain landscape. A rainbow in nature is a visual illusion created by minuscule water drops caught in the sun's rays. Although it lasts just a few moments, it is a mesmerizing and exhilarating sight that artists have exploited in many forms, sometimes with great success (see Hicks, page 68), but rarely with the vigor exuded by Hodgkin in this work. The picture here exists within a tilted rectangular opening that seems to have been cut from the red dotted scrim, but it does not align with the frame's sight opening. This allows us to see the red marks (water drops?) as closer to us than the landscape, which increases the spatial illusion and unifies the canvas by hovering above its wooden frame.

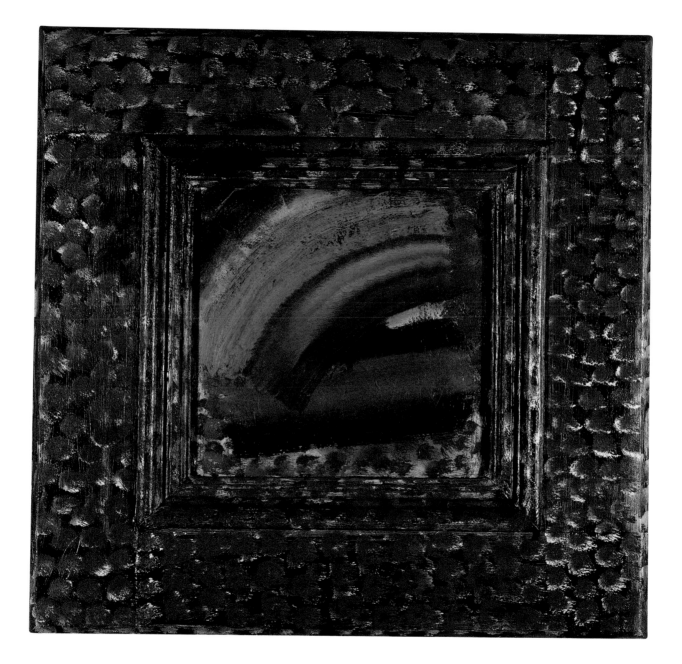

With tongue firmly in cheek and with a nod toward the tradition of the Great Work exhibitions, Peter Blake, like Frederic Church with his freestanding presentation of *Heart of the Andes* a century earlier (see p. 33), has created here a large architectural framework and filled it with an enormous number of items, so many that the viewer is overwhelmed at first, unable to take it all in. Blake's work, like Church's, is infused with the spirit of his time.

Having graduated from the Royal Academy of Art in the late 1950s, Blake blends the academic training he received there with collage elements garnered from his active engagement with contemporary popular culture. His art reveals his idiosyncratic interests: heroes and heroines, celebrities, pinups, literature, film, wrestlers and boxers, toys, and freaks. Blake also utilizes a wide variety of media in his work, including painting, collage, wall-mounted and freestanding construction, found objects, and printed matter. He incorporates etching, engraving, serigraphy, and lithography, often printed on unorthodox materials, as in the well-known image of *Babe Rainbow* (1967), a fictitious female wrestler. Ten thousand posters of *Babe*, silk-screened on tin sheets, quickly sold out and became a ubiquitous part of the decor in swinging London and hip America in the 1960s.

For *Toy Shop*, Blake used a door and a shop window front he found at a building site in West London to create another image that adroitly combines usually opposing aesthetic camps: the pure abstraction of formalist balanced shapes, in this case rectangles, and the nostalgic, image-laden world of figurative collage. As a bas-relief sculpture, the architectural elements of this presentation frame are a discourse in minimalist, classical harmony, a variation on the subject of the rectangle, similar in spirit to the work of Mondrian (see p. 106).

The shop window, with its bright lights and colorful imagery, stands out from the rest of the painted architectural elements, starting a dynamic play of proportions that moves clockwise to the stabilizing rectangle of the base and then to the vertical door with its four coffered panels. At the top of the door, after reading the sign, we tumble back into the window, where two rows of panes break up the surface into separate vignettes filled with imagery that has a distinct, engaging dynamic of its own.

Toy Shop is a tour de force of window dressing. Carefully crammed to feel chaotic, the array of items is staggering. Every section is a rhapsodic evocation of 1940s and 1950s childhood memorabilia, including art supplies, a reference to Blake's early choice of career. From the sublime to the ridiculous, there is something here to jog the memory of parents, the customary givers, as well as children, the customary recipients. This is a contemporary stand-alone picture, architecturally sound, formally engaging, brimming with associations and ideas. It strikes a deeply satisfying balance between reality and fantasy, between the pragmatic and the imagined, indisputably unifying frame and content.

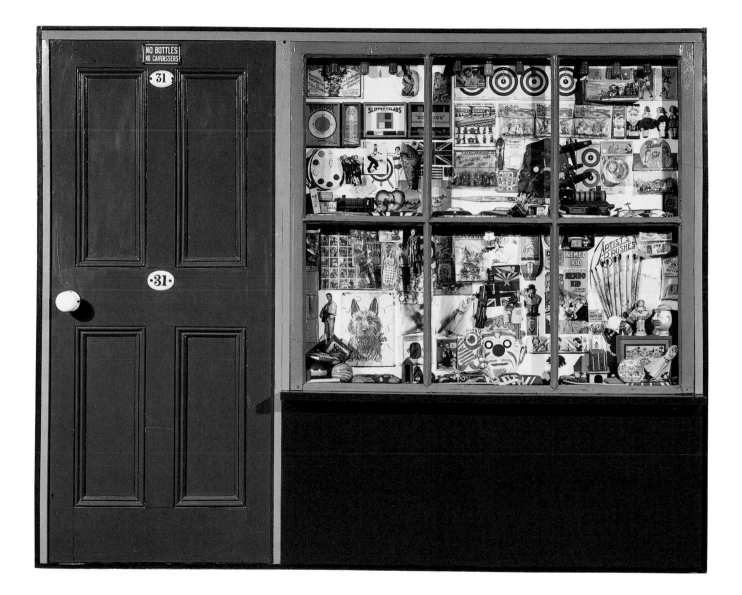

3

THE FRAME AS DECORATION

Decorated picture frames are one of many forms in the field of decorative arts, a product of fine design, materials, and craftsmanship. But unlike a chair or a lighting fixture, the frame has always had a special role to play—to set off the work of art from its surroundings, as well as to help it fit into its setting and to impress the viewer with the owner's wealth, taste, or power. While a significant painting may inspire the frame-maker to produce a unique and distinguished frame, the risk with a lesser picture is that an elaborately or inappropriately decorated frame will overwhelm the work or draw attention away from it. Many frame-makers have been the same artisans who make door frames and chair backs, using the same tools and techniques, the same decorative motifs and styles. The highest quality frames, however, have always been those whose makers have made a connection with the work of art for which the frame was intended.

The techniques used in decorating picture frames are usually an intrinsic part of the construction of the frame itself and offer an infinite variety of options. One may use carpenters' tools to chisel shapes in wood or gesso or to incise or punch patterns; modeling material can be built up to create low-relief patterns or decorative elements; semiprecious stones or paint or sand may embellish a plain, flat surface.

The types of patterns used as decoration on picture frames are usually dictated by the period in which the frame was made and the fashion-consciousness of either the artisan or the owner of the picture. Grotesquerie in fifteenth-century Italy, flower imagery in seventeenth-century Holland, and exotic oriental motifs in nineteenth-century England found their way onto all manner of objects, including tapestries, furniture, and wall decorations, and frames were not exempt from these motifs-of-the-moment. However, as the following examples indicate, stylish decoration often reached a very high level of quality without diminishing the impact of the work of art, thus fulfilling its function to attract without dominating.

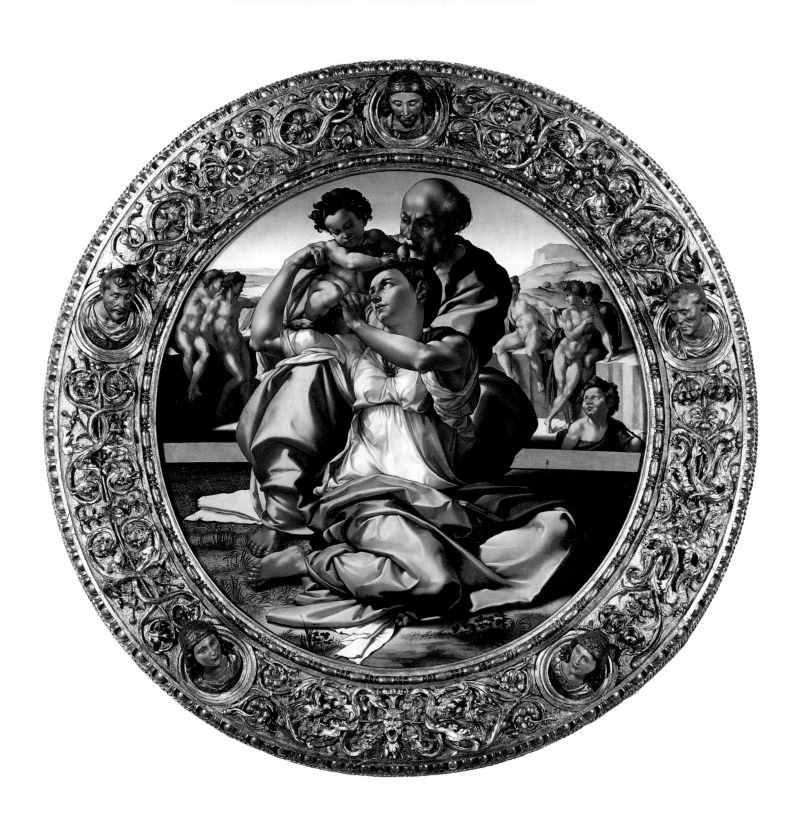

Michelangelo himself designed the tondo frame for his painting of the Holy Family, familiarly known as the *Doni Madonna* after its probable patron, Angelo Doni. The frame was made by Antonio Barile, a Sienese woodcarver famous for his frames, monumental statues, and church furnishings. A supreme example of High Renaissance art, this ensemble represents the egalitarian relationships between painting, architecture, sculpture, and decorative arts during the early sixteenth century.

The frame is constructed of inner and outer profile rims with simple classical motifs that surround a wide panel covered in an array of entangled vines, birds, and masks, each masterfully designed and executed. At the bottom center is an open-mouthed mask from which grows a vine whose tendrils twist around the central stem. Each of the five separate sections of the frame is a unique variation on the theme: mirrored branches that spiral toward one another and end in what look like flower buds but are, in fact, delicately carved three-quarter relief sculptures of fanciful masks, many with their mouths wide open.

This type of decoration, called grotesquerie, derives from the caves (*grotte* in Italian) where these motifs, painted on walls, were found by archaeologists excavating ancient Roman ruins. As a decorative design form, a grotesque image often consists of a distorted human face (or mask), an imaginary beast, a hybrid animal-human creature, or fanciful plant forms combined in an elaborate surface pattern. This style of ornamentation became very popular during the late fifteenth century in Renaissance Italy and found its way onto nearly every surface that called for embellishment, including frames. Grotesque decoration was so much in vogue that no less an artist than Raphael, working for the pope, formulated a refined version of the grotesque that became a model for European decorative artists over the next few centuries.

In addition to the masks, Michelangelo's tondo frame is decorated with five medallions from which protrude the three-dimensional heads of five prophets. The human head was often used as an ornamental motif during the first half of the sixteenth century, on circular moldings, inspired by Roman coins on which emperors were depicted or by Byzantine decorations for icon covers. Michelangelo, however, has taken the motif to a new level in this frame. The prophet at the top gazes solemnly downward, directly observing the Holy Family, and he seems to invite us to follow his gaze. (See the Friedrich frame for a similar use of this device, p. 25) The two prophets at the bottom serve as gatekeepers, who intercede between the illusion of the painting and the world we occupy as viewers. The direction of their gaze makes us aware of an open space at the bottom of the frame and in the painting, a kind of channel for us to enter the picture at ground level before our gaze is drawn upward in a sweeping S-curve that culminates in the loving looks being exchanged by mother and child.

The prophets are strategically located, each at the tip of an imaginary five-pointed star. This placement, which is an unusual variation on the traditional four-point cruciform arrangement on Renaissance frames, counters the purity and symmetry of the tondo shape by adding a dynamic element to a normally static form; the star interacts on a formal level with the painting's composition by anchoring the Holy Family group within the circle. The carved heads provide a contrast with the rest of the frame, not only because they project beyond its surface but also because their naturalistic color, unlike the gold of the frame, connects them to our world. They reassure us that we may enter and become part of this intimate humanistic and allegorical scene.

The seventeenth-century frame that surrounds this equestrian portrait is a fine example of Italian grotesque decoration, Spanish style. Bold-featured satyr masks, their mouths agape, scream at us from the corners and sides of the frame. The artisan who made this frame probably appropriated popular motifs from Italian pattern books and added them to his ensemble of elements in a style characteristic of Spanish frames of this period. The robust carving is quite unlike the shallow surface ornamentation seen in French frames, where delicately carved bas-relief leaves and flowers flow evenly around the perimeter (see Ingres, p. 51).

Here the carved wood has been gilded and then rubbed to allow the red clay undercoat (bole) to warm the gold and to color some of the carved edges. The burnished surface of the gilded portions and the depth of the frame are emphasized by the recessed cove, which is painted black, a traditional Spanish technique.

The three satyr masks on the bottom of the frame face in our direction, as if to protect the nobleman in the portrait. They lend stability to the base of the frame, supporting the image of the duke on his horse and keeping us at a respectful distance. The other five masks disappear into the decorative design of the frame; the central head at the top is nearly undetectable because of its similarity to the motifs that surround it and because it is upside down and does not read as a face.

The decorative context in which the masks are placed includes several classical motifs—palmettes, double volutes, egg-and-dart, ribbon-and-stick—which are simply and strongly carved, like the masks, and lend a hearty muscularity to the frame. The beard of each satyr overlaps the outer ribbon-and-stick border, breaking up the regularity of the perimeter and initiating a dynamic asymmetrical rhythm of forms around the frame. The carved motifs match the robust character of the subject—an equestrian portrait in which the rider performs a classical movement—and handsomely complement the decorative elements within the picture, such as the horse's tail, the golden straps on the horse's caparison, the duke's armor, and even the smoke curling up from the city below.

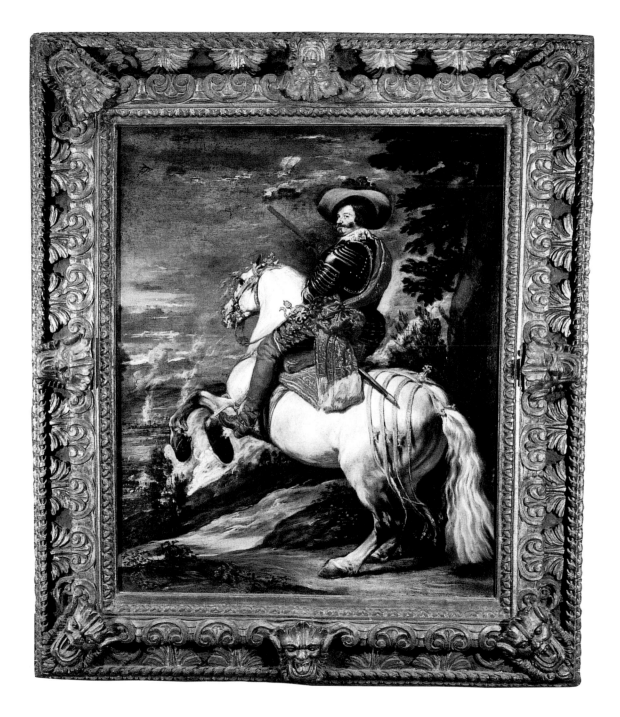

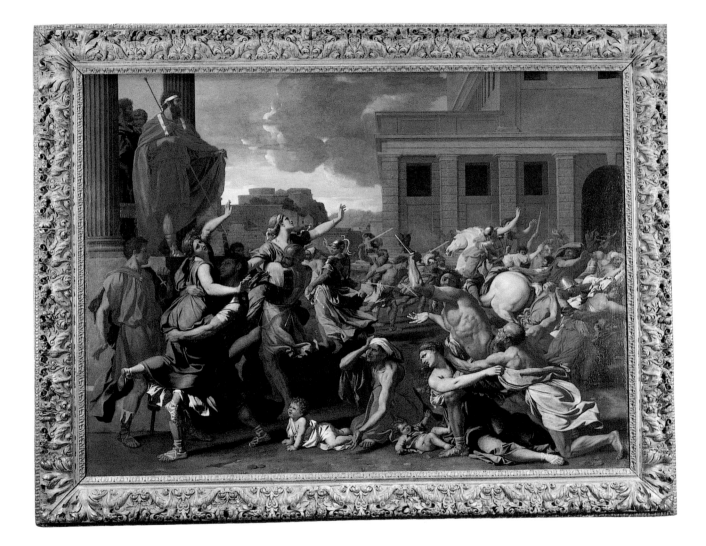

NICOLAS POUSSIN (1593/4–1665)
The Abduction of the Sabine Women, c. 1636–37

Attesting to the longevity of the grotesque form in frame design is this nineteenth-century example, which surrounds this large Neoclassical painting, one of Poussin's masterpieces. The combination of a seventeenth-century painting with a nineteenth-century frame is not uncommon; art collectors, dealers, and museum curators often replace frames either to keep pace with current fashion or to give paintings the stamp of ownership. It is because of this tradition that there are so few great paintings still in their original frames, or even appropriate period frames. We know, for example, from Poussin's letters that he gave his paintings plain moldings with dull gilding. Nevertheless, this elaborate frame is distinguished by the sensitivity of its design, especially in relationship to the picture it encloses.

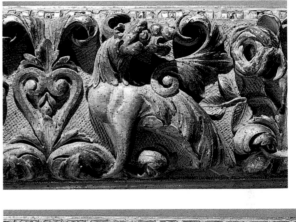

A large acanthus leaf, carved in low relief, leads us graciously around each corner of the frame and conditions us to accept the rest of the motifs as plant forms, which is not in fact the case. What appears at a distance to be a repeated swag motif around the frame directs our attention to forms within the painting as it reflects light from different angles. On closer inspection, we see that there is no swag at all, rather a series of paired gryphons that confront each other across a flowering plant. As we step back again to view the complete painting and frame, the creatures assume their camouflage as design elements and recede into the complicated texture of the frame. Since we now know they are there, we are able to discern them above the horizontal cove at the top edge of the frame.

Unlike many old master paintings, this Poussin has been well served by the choice of frame, whose classical motifs relate to the static poses of the figures and whose carvings catch the light in a manner that mimics the artist's carefully controlled use of light over the forms in the painting itself.

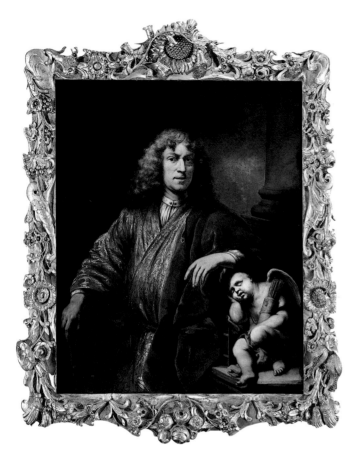

A full appreciation of the magnificently crafted frame around Ferdinand Bol's 1669 self-portrait requires some understanding of the social and intellectual climate in which it was made, particularly the guild system within which artist and artisan worked. Both frame and painting were produced during the Dutch Golden Age in seventeenth-century Holland. Rembrandt, Vermeer, and other northern European old masters came into their own during this period of intellectual and scientific exploration of the physical world. The phrase "God is in the details" expresses the idea that permeated all levels of Dutch society at the time and distinguished it from other European cultures. The Italians believed that man was the measure of all things, an outward directed approach to viewing the world. Dutch culture, on the other hand, reinforced an intense focus on the minutiae and the significance of everyday reality, and the role of the artist and the artisan was to convey this approach in images and objects.

Bol became an independent master of portraiture about 1662, having worked with Rembrandt for many years. This self-portrait was made as a bridal gift to his second wife, and it has all the elements of a presentation painting, not simply because of the quality of the portrait but also because of the highly decorative frame that he commissioned for it. The lavish use of ornamentation would surely have impressed his bride, and the symbolic content of both frame and painting must certainly have convinced her of his virtues as a husband. The dozing Cupid, for example, would seem to indicate that the god of love no longer needs to work on Bol's behalf.

The frame is a perfect foil for the painting and it reflects the artist's awareness of contemporary fashion in its three-dimensional interpretation of the Dutch flower style, which reached its peak during the seventeenth century. The cultivation of exotic flowers, particularly tulips, merged with fashion and a popular interest in botany to become one of the most popular themes in Dutch still-life painting and the decorative arts, notably silverwork. Bol was undoubtedly also aware of the Flemish tradition of using painted floral wreaths and garlands to frame portraits and other images. Sunflowers, a traditional symbol of adoration, are the predominant flower in this frame, but several other types of plants are included, such as the rose (love), the grape (charity), ranunculus (radiance), campanula (gratitude) and even corn (fertility), a recent import from the Americas.

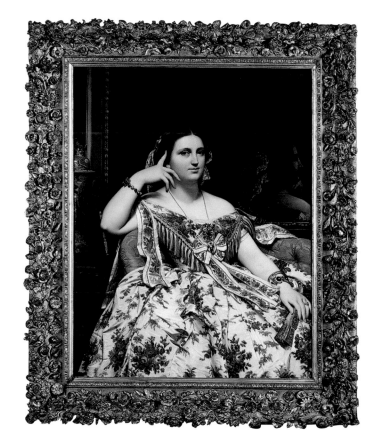

The frame that Ingres designed for his portrait of Mme. Moitessier is a perfect complement to the painting. Although the trustees of the National Gallery in London ordered its removal when the portrait was acquired in 1936, the frame was later reinstalled, and the two have remained together ever since. Aesthetically, they are bound together inextricably, a union of opposites. Luscious flowers are the only common denominator, and there are abundant variations on the floral theme in both the elegant portrait and the no-holds-barred frame that encloses it. The painting is restrained, but the frame goes over the top, with wild, vigorous, grasping forms. A leafy vine ripe with buds and flowers appears to grow as we look at it, like a time-lapse sequence of a blossoming plant.

It is the fecundity of these images that alerts us to the contrast between the painting and the frame. The straight outer edge of the frame molding is interrupted by the uneven rhythm of the overhanging blossoms, buds, and leaves, and there is no careful repetition of motifs, as in most other French frames of this period. The vine appears to be growing in a clockwise direction, engaging our peripheral vision as we focus on Mme. Moitessier. Our eye moves around her figure as it moves around the frame, and we become aware of the slightly off-center pyramid created by the figure and dress. Even the dramatic hand at the side of her head—one of the most analyzed hands in art history—has a clockwise movement, its fingers marking the hours one, four, five, six. It is only on the inside of the frame that unbroken straight lines occur in two parallel bands, the first decorated with carving and the second a simple cove, which eases our gaze into the meticulously detailed world of the painting.

A comparison of the actual frame and the frame of the mirror painted on the wall behind Mme. Moitessier reveals a stylistic disparity, a subtle reminder of how nature can be tamed by design. The painted frame is typically Neoclassical, with an elegantly curved outer edge that lies parallel to a thin interior ribbon carved in a precisely repeated leaf-and-stick motif, the only decorative element on the frame. Unlike the real frame, this painted version is consistent with the civilized milieu occupied by the subject of the portrait. The artist is placing us in the world of the outside frame, not in the perfect world of Platonic ideals.

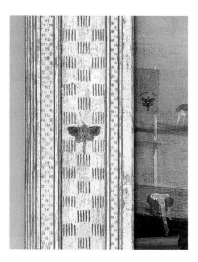

The American-born Whistler, who spent most of his life abroad, would be almost as well known for his frame designs as for his paintings, if it were not for the portrait of his mother. He devised a number of different types of frames in which he used an infinite variety of gilt finishes, patinas, and paint to achieve tones or patterns that harmonize with the paintings they surround.

In the 1870s, like many other artists in Europe, Whistler came under the influence of Japanese art. He began to introduce Asian objects into the scenes he painted and to explore the use of asymmetrical compositions, which tend to emphasize the flatness of planes within the picture. To reinforce that flatness, Whistler used wide horizontal panels in his frame designs. At first he made frames with abstract, low-relief Chinese or Japanese motifs, usually placed at the corners and in the middle of each side; later he devised another type of frame that had fine reedlike moldings on the exterior and interior edges. He also painted Japanese motifs on the frame panels in whatever tone predominated in the painting itself. These painted patterns were derived from woven tatami mats, overlapping fish scales, circles, and spirals, and they serve to extend the flat planes within the painting to the outside edge of the frame, where it meets the wall.

Whistler's *Variations in Pink and Gray* has a frame with a wide, smooth panel, decorated with simple painted tatami-mat motifs, a five-stroke pattern in the center panel and a three-stroke pattern on the two thinner panels to the right and left. The left vertical panel also contains Whistler's famous butterfly monogram, painted in a striking russet tone that makes it seem to hover just above the gilt surface. Slightly above and to the right, just inside the sight edge of the frame, is a smaller dark-gray variation of the butterfly mark within the painting itself, where it appears as a design on the sail of a fishing boat. By putting the two butterflies so close together and connecting the sail shape to the inside edge of the frame, Whistler further emphasizes the shallow depth of the picture and therefore controls precisely what the viewer encounters out to the edge where the frame meets the wall. Later, he extended this control farther by painting the walls of the gallery in neutral colors that complemented the tones in the pictures.

So important to Whistler was the inseparable relationship between frame and image that in at least one case he did not sign the painting at all but simply painted his butterfly symbol on the frame. The butterfly was his version of a copyright symbol, an attempt to ward off pirates who might have stolen his carefully designed frames. In spite of his efforts, unauthorized copies of his moldings with parallel reeded lines found their way into the marketplace in a variety of forms of uneven quality; even today these are sold commercially as Whistler-style frames.

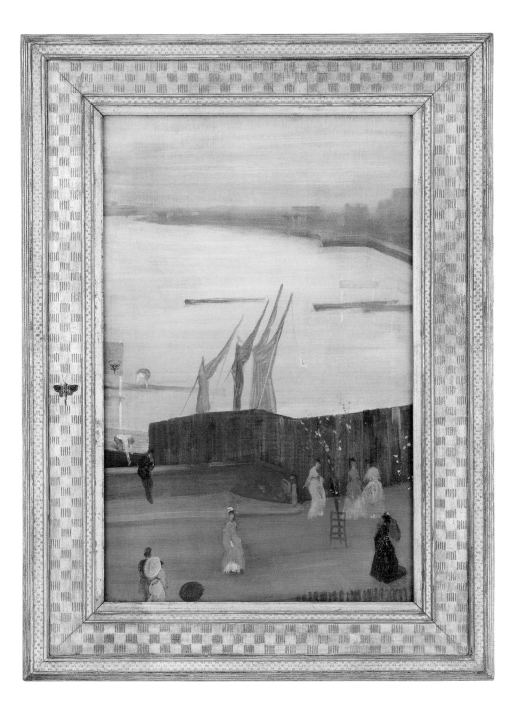

ATTRIBUTED TO USTAD MANSUR

Emperor Jahangir receiving Prince Pariz. Indian, Mughal dynasty, 1610–14

Mughal miniatures like the one illustrated here are often viewed by the Western eye as decorative images where the artist has made no attempt to provide a sense of depth. This, of course, tells us less about the limitations of the miniature painter than it does about our own, confident as we are in the value of what we call linear perspective, which succeeds so well (for us) in creating the illusion of receding space. Persian-trained artists who flourished in the court of the Mughal emperors in India during the seventeenth century developed an utterly different set of devices to convey depth on a page, of which the frame was especially effective.

Because these paintings on paper were not intended for display on a wall but were bound into books, they were not framed in the usual sense; however, their intricate borders can be interpreted as a series of framing devices. Surrounding this painting is a wide band filled with several painted areas: some thin, others wide; some covered with intricate floral patterns, others with calligraphy. The outermost band contains a subtle all-over pattern composed of delicate silhouettes of plant forms growing upward from the bottom of the page. The interior borders and the picture itself appear to have been placed on top of this sheet, but a closer look reveals that everything has been painted on the same page.

On the inner edge of the floral band the artist has painted a succession of lines around the picture. The outermost black line brushes against the leaves or slightly overlaps them, to create a sense of shallow space, like a surveyor's string staking out a new area to develop in a garden. Inside this line is what looks to us like a three-dimensional rectangular molding, made up of a band of gold wash edged on the inside with two lines, one green and the other a luminous violet. The next interior band is composed of gold spatters that form a ribbonlike floral filigree pattern, whose four corner units guide your eye around

the intersection, like the corner designs on Italian Renaissance cassetta frames. The widest band, next to the picture, is a dazzling array of cloudlike elements filled with calligraphy, reminiscent of the stylized cartouches on Japanese prints (see Hiroshige, p. 34). These forms float on a gold background covered with delicately intertwined vines encrusted with tiny jewel-colored flowers. At the sight edge of this frame is a striking orange line, which at last announces the picture itself.

The scene, a royal meeting, is filled with framing devices that the artist has used to guide us through a variety of spaces. A sequence of four dramatic rectangular frames articulates a courtyard situated in a receding landscape and moves us rapidly through the two assembled groups. As is characteristic of much Asian art, our vantage point is well above the scene. Three sides of a white rectangle placed slightly left of bottom center form the sides of a pool into which we can look directly. The raised platform beyond the pool is covered with another frame unit—a dark blue floral carpet whose gold medallion is placed slightly to the left of the picture's center. The pool and the carpet serve as stepping stones through the open central corridor that separates the two clusters of men. Behind the emperor and his visitor is a third frame, an opening in the garden wall through which one can see a flowering bush and a cypress tree. This doorway serves to focus our attention on the clasped hands of the two rulers, but it also opens up a vast landscape beyond the high wall. It is not surprising that a number of Western artists were drawn to this kind of painting. Rembrandt, a contemporary of Mansur's, had a large collection of them. Henri Matisse also came under their spell; he reinterpreted their areas of decorative pattern used to animate flat surfaces and absorbed into his own painting the formal arrangement of discrete framing units to create a sense of depth without relying on Renaissance perspective.

A procession of silhouetted stags seems an utterly incongruous motif for a frame surrounding a delicate colored etching of flowers, but somehow the combination seems appropriate for the Victorian period, during which exotic eclecticism was the order of the day. Roussel, who was born in France but worked in England from 1874 on, was a minor painter and printmaker. This wonderfully decorative combination of frame and image is brilliantly expressive of the period in which it was made, from both a technical and an aesthetic point of view.

By the nineteenth century, wood moldings could be milled quickly with intricate profiles, coated in a wide variety of finishes or veneers, and sold to frame-makers who would cut them to size to fit their clients' pictures. No longer were frames hand-carved from blocks of wood; no longer were craftsmen sought after for their skills and knowledge of materials and techniques. Frame-making had become a partnership between designers and manufacturers, and the variety seemed infinite. The potential for excess and decorative disaster by the producers was very high and was, unfortunately, frequently achieved, for frame-makers could indulge any client's wildest desire with ease and at relatively little expense.

Sometimes, however, a sensitive artist or framer could take advantage of the diversity offered by mass production and assemble a pleasing frame with a great deal of originality and arresting imagery. Roussel seems to have had just the right eye to select from stylish Victorian frame types a surrounding for his vase of anemones. Here is a case in which design prevails completely over content.

The naturalistically rendered image of the flowers is dramatized by the black frame that encloses it, creating the impression of a window whose black velvet curtains have suddenly been drawn apart to allow sunlight into a dark room. The surrounding chalk-white border is decorated in a swirl of delicate gold lines that depict plant forms freely drawn in natural arabesques and swirling in a clockwise motion around the central vertical image. This activity helps ready us for a shift in proportion, for a squaring of the exterior edge.

A single hand-drawn line in a classical fretwork design runs around the outer edge of the white surface, just inside the sight edge of the frame. This flattens the white surface and prepares the eye for the straight-cut inside edge of the wood frame. A series of alternating oak- and walnut-colored bands in varying widths move outward, gradually widening until they culminate at the outer edge in a flat, tightly grooved molding.

The most striking elements of the wooden frame are the top and bottom panels on which the stags are silhouetted, each in a different position, frozen as in a Muybridge photograph sequence of animals in motion. On the top panel, the stags move from left to right, but at the bottom, two stags enter from opposite sides to butt heads in the center.

One of the most prevalent decorative modes of the late Victorian era was the taste for "oriental" motifs and styles. Whereas many artists looked to Japanese prints, others were drawn to Indian or Persian designs as seen in manuscripts, carpets, and other textiles (see p. 54). A feature of some Persian miniatures, for example, was the use of several "frames" around a central image, some with calligraphy and others with figures of animals in various positions, usually connected by plant forms. Although this Roussel concoction is clearly not a copy of any Asian original, the artist was definitely familiar with examples of Persian painting.

4

THE FRAME AS CONTENT

A frame may enhance a picture not just by dressing it up or by setting it off visually and intellectually, but also by complementing the painting in a way that adds to our understanding of its subject. The role played by the frame can be to manipulate the viewer's perception—emotionally or even politically—according to the intentions of the artist or owner. The Duplessis portrait of Franklin, for example, is embellished with motifs that imbue the picture with patriotic American content. A portrait's frame may also expand the viewer's experience of the work by identifying the sitter (as coats of arms did on early portrait frames) or by giving additional, sometimes more detailed information, usually through symbolic or naturalistic images carved, inscribed, or painted on the frame, as in the Eakins, Stettheimer, and Sherman examples that follow. The frame around a landscape painting may serve to identify the setting (see the Hicks and Hawkins paintings of Niagara Falls), or it may even become part of the action (see Paul Klee). A frame rich in symbolic imagery can help stimulate an emotional response, as it does in the Pippin and O'Halloran paintings; more realistic images, like those on the Smith and the firemen's trophy frame, take on a narrative role explaining or summarizing the event being depicted.

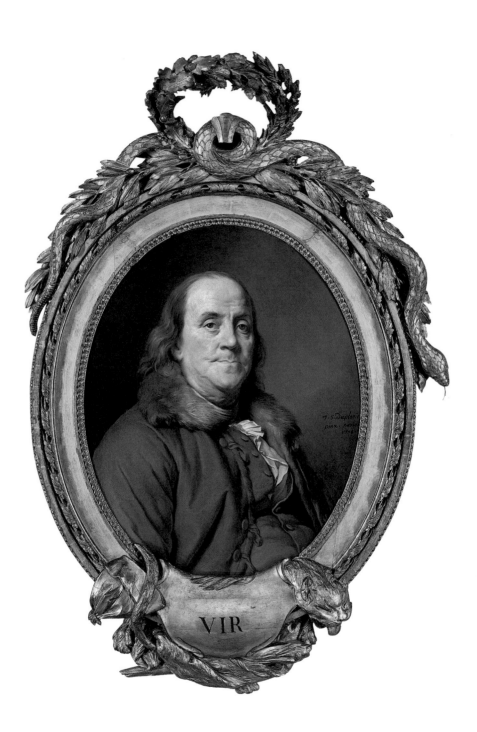

A narrative frame full of optimism, friendship, and the fraternity of two governments surrounds an oval portrait of Benjamin Franklin painted by the French artist Joseph Siffrein Duplessis during the period of Franklin's ambassadorship to France. An international celebrity, Franklin arrived in France in the autumn of 1776 to negotiate aid and alliance for the newly independent American nation. His wit, intelligence, and political acumen, along with his simple attire, made a positive impression in intellectual circles. Jacques Donatien Le Ray de Chaumont, Franklin's host, commissioned this portrait, which was first exhibited in the Paris Salon of 1779.

The period frame made for the painting is a straightforward, splendidly executed version of an eighteenth-century Neoclassical frame, in which the outer raised band, or fillet, surrounds a spiral leaf-and-stick motif that moves your eye around the oval. Within this is a broad, flat panel that has a carved inner lip beginning next to the painting. This style of frame often has an elaborate carved finial at the top, typically a garland of flowers with leaves and ribbon. At the bottom there is usually a shield or scroll (cartouche) surrounded again with foliage and often inscribed with the name of the sitter. This is the type of frame commonly seen in European and American galleries and museums.

The frame on Franklin's portrait is a remarkable variant on this familiar form, because it contains unique additional elements interspersed with the usual motifs. The elaborately carved top, which seems to spill down the sides, contains a robust union of Liberty (snake), Peace (olive branch), and Victory (laurel wreath)—symbols representing the American government. The bottom of the frame has what appears to be a flayed muskrat with the inscription VIR (The Man) , perhaps a reference to the fur trade. This is an eccentric, engaging alternative to the formal engraved coats of arms that often adorn paintings of political or royal figures. An understanding of the symbols on the frame enhances our appreciation of the portrait and gives us a sense of how esteemed Franklin was as a statesman.

The great American artist Thomas Eakins was deeply concerned with the frames that surrounded his paintings. He designed a large number of them and had them executed by artisans he knew and trusted, or else he made them himself. He devised a strikingly fresh, seemingly modern frame for the portrait of his friend Professor Henry A. Rowland, a noted Johns Hopkins University physicist who studied the properties of light. This was not the first time Eakins had designed such a frame to complement a portrait; in a letter to Professor Rowland, he wrote: "I once painted a concert singer and on the chestnut frame I carved the opening bars of Mendelssohn's *Rest in the Lord*. It was ornamental, unobtrusive and to musicians, I think, emphasized the expression of the face and pose of the figure."[1]

The frame is direct and simple in form, consisting of four wide, flat planks of gold-leafed chestnut, mitered at the corners. The entire surface is covered with what appear to be graffiti, although a closer look reveals an arrangement of scientific jottings: equations, symbols, numbered scales, graphs, and diagrams, all drawn by the same hand and most likely extracted from the professor's notebooks. These marks serve to describe the sitter's occupation, but they also give us a glimpse into the workings of his mind. Eakins has used the frame to involve us with his professor friend so intimately that we feel that we participate in his thoughts as he gazes into the light that flows from outside the right edge of the painting.

These notations on the frame also link the artist and the scientist as creative individuals interested in the properties of light. Rowland researched its physical properties, while Eakins explored the use of light to illuminate both form and character in his subjects. They each used a pen and a notebook to explore original ideas and undeveloped theories, to work out compositions or equations, and to make everyday observations related to their particular disciplines. Diagrams and equations descend, stacked from top to bottom, along the right side of the frame below the circle in the upper right corner. This row of complex but loosely drawn notations effectively blocks us from following the professor's intense gaze as he looks toward the source of the light.

Our eye moves down the right side of the frame, row by row, until we reenter the painting near the image of his shoe at the lower right, guided by the exposed miter. These mysterious marks, then, perform another function for the viewer. By arranging random notes into an organized pattern, Eakins manipulates us to interact constantly with both the painting and the frame on a formal level. The left panel, for example, has a wonderful lyrical movement, thanks to the large, free-flowing letters, numbers, and other marks that scrawl their way along the full length of the side. This rhythm is completely different from that of the other three sides of the frame. When we reach the top left corner, the exposed miter joint captures our attention, just as its counterpart at the lower right has done, and we are again pulled back into the painting. The horizontal orientation of the top and bottom panels serves as an effective contrast and stabilizing element for the dynamic movement created on the sides.

What could have been another serious and sober nineteenth-century portrait is instead an absorbing and delightful exercise in discovery, enriched by narrative frame designed by the artist to augment both the painting and its subject.

1. Theodor Siegel, *The Thomas Eakins Collection* (Philadelphia: The Philadelphia Museum of Art, 1978), p. 128.

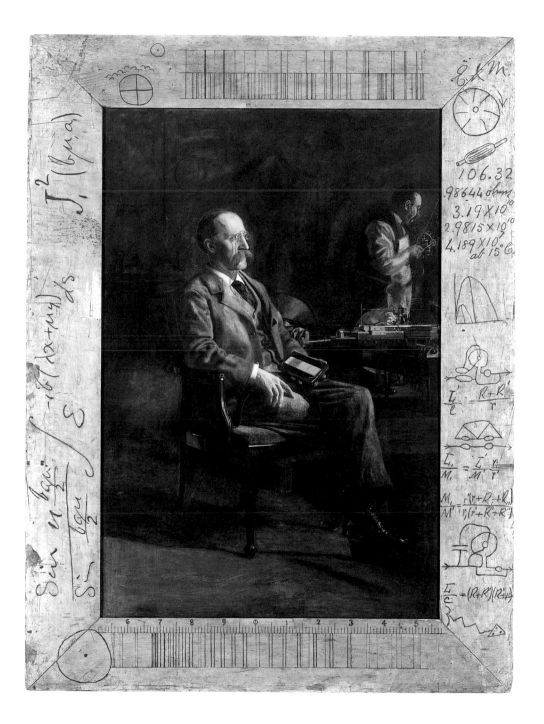

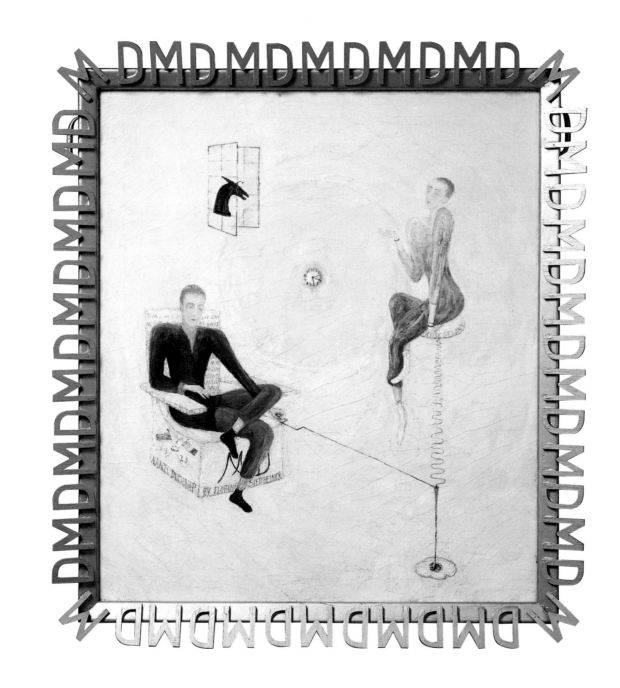

Louis XV, the king of France from 1710 to 1774, had a style of frame named for him, the one we usually mean when we refer to a "French" frame. A good antique version will have beautiful, richly carved scallop-shell corners, elegantly swagged panels, lots of random buds and flowers, and a marvelous, soft-gold finish. The American artist Florine Stettheimer undoubtedly saw many of these in her European travels, and in 1923 she designed her own modern version, a stylistically appropriate, inventive frame to surround her portrait of Marcel Duchamp, king of the avant-garde.

Stettheimer studied painting in Europe for nearly three decades, attending a variety of art schools and becoming well versed in contemporary art movements. A frequent visitor to salons and artists' studios wherever she went, Stettheimer befriended artists, collectors, and dealers and made fanciful portraits of her friends in stylish clothes and settings. When a painting was completed and ready to be seen, it was usually unveiled in grand style, either at her New York studio or at one of the legendary dinner parties given by Florine and her two sisters, Carrie and Ettie.

Duchamp was an important member of the Stettheimer circle, and his respect for Florine's paintings validated their unique position within the contemporary art scene and ensured their exposure to enthusiastic critics and collectors. *Portrait of Duchamp* features an inventive arrangement of symbolic images relating to Duchamp, including a monogram of his initials, his invented female counterpart, Rose Selavy, a crank from the *Chocolate Grinder*, a chess piece, and a clock with a radiating halo.

The frame material Florine Stettheimer used for this portrait resembles the gray metal Duchamp used in his machine imagery. An inward-sloping bar supports a series of stamped-out letter forms, "M" and "D," which are repeated, assembly-line fashion, around the four sides of the frame. Stettheimer's idea of a picture as a fragment of some larger field, temporarily isolated but, like a film frame, with its own sense of stopped movement, is reinforced by the severity of the frame. As art historian Anne Hollander writes of Stettheimer's work, "the frame itself seems to be moving through space and the action inside it perpetually going on. The eye may move over it or even in and out of it, with the random scan it uses on real life. . . . Like film it suggests a great deal more than it states and makes strong if unarticulated demands on the individual viewer."[1]

By virtue of its assembly-line, staccato movement, the frame adds a mechanistic dynamism to the outer edge of the portrait and reiterates the expanding circle of the interior clock. To trap this activated, free-fall universe Stettheimer has made a frame fit for a king.

1. Anne Hollander. *Moving Pictures* (Cambridge, Harvard University Press, 1991), p. 21.

In 1990 Sherman showed a group of thirty-five photographs in a solo exhibition entitled "History Portraits" at Metro Pictures in New York City. These are large photographs of reconstructed tableaux loosely based on paintings done in many styles over several centuries from different parts of Europe, such as the quattrocento in Florence, the Northern European Renaissance, and the nineteenth century in Paris. All works are listed in the catalogue as *Untitled*, as is customary for Sherman, followed by a catalogue number and the date, along with the size, which, interestingly, includes the outside dimension of the frame and a notation as to whether the frame is wood, gold, or silver. Clearly the frames are an integral part of the presentation of this body of work. One could not purchase a piece from this series and reframe it without destroying the artist's intention.

Each frame was selected to nudge the viewer into the territory Sherman mapped out for a particular tableau, a region where art-historical specifics are purposefully vague. She uses the frame to confuse our orientation and to lead us into an arena where our memory plays tricks on us (Where have I seen this painting?) or fails us completely (Who is this artist?). We are muddled and frustrated, right where Sherman wants us. We are confronting a contemporary tale based on a serious work of art—historical, yet elusive—which defies our attempt to place it precisely in the past, thus calling into question the very notions of past and present. The frames in this series, like the photographs themselves, do not pretend to replicate an existing historical artifact. In truth, they play with our collective memory of art history.

Surrounding *Untitled # 211*, an image of a woman in profile similar in character to a number of paintings by Hans Holbein, is a frame with the generalized attributes of a portrait frame from the Northern Renaissance: a simple fabrication containing a rectangular panel with an oval opening set in a sturdy, rectangular outer molding. Both panel and molding have a luminous ebony finish, and Sherman makes no attempt to disguise the fact that this is not an old frame. It has none of the contrivances of a facsimile reproduction, such as artificial signs of distress involving nicks and pits, or a purposely shaved molding to relieve the straight cut of modern machine tools, or a spattering of rotten-stone powder to simulate dust and age. It is clearly a new frame, which sets off a modern photograph. What is remarkable is that the frame and the tableau photograph function in concert. Created to reinforce each other, they have been calculated to call into question our ideas about portraiture then and now: Where are we? What do we think? What is a portrait? What is this portrait? What is its value and meaning?

The frame teases us by conveying significance and stature through obvious allusions to substantial and respectable European artifacts, as it dares us to resist attributing undue importance to a blatantly new object. We feel as if we have seen this work before in a museum, but we also suspect that all is not as it appears. Sherman's work rings a bell and sets off alarms all at once, making us the willing victims of her droll deception.

Two wonderfully different frames and paintings share the theme of Niagara Falls, one by the American folk artist Edward Hicks and the other by the American outsider artist William Hawkins. Both artists were self-taught, and both clearly shared an interest in this grand environmental extravaganza. Each artist in his own way provides an interpretation of the falls that fairly bursts with patriotic gusto, a sentiment made more exuberant by the frames that surround them.

Both artists used published images of the falls to produce their own compositions. It is well known, for example, that Hicks used a variety of sources in his many versions of *The Peaceable Kingdom:* Bible illustrations, engravings after Raphael, nature pictures, and so on, and it is likely that he did the same here. Hawkins also scavenged images from books, catalogues, and popular magazines, culling everything that attracted him and storing clippings in a special suitcase that held decades' worth of his picture archives.

Edward Hicks chose to depict Niagara Falls in somber tones of brown and gold, an odd color selection for a scene filled with water and spray, animals and trees. He may have chosen these colors because he was working from black-and-white images, or perhaps because they harmonized with the frame's warm-colored wood and gold letters. In any case, it is clear that the artist spent a good deal of time on the frame, which recalls early Renaissance examples on which inscriptions were meticulously hand-lettered in gold leaf. Here Hicks has painted a double line of rhymed text (from Alexander Wilson's *The Forester*, 1909–10), which flows clockwise around the frame, separated from the painting by a gilded lip that acts as a base line for each stanza. This ledge generates a pathway for the eye around the interior periphery of the frame and then into the painting itself, stabilizing the wildness of the downward-rushing falls and the upward-spewing spray. The lettered title, *Falls of Niagara*, is set above the picture, outside this turbulence, on its own wooden frame. Although the title appears in upper-case italic letters and is therefore visually stronger than the poetry beneath, it comes across as neither stately nor rigid but as an expression of sincerity tempered with a dash of salesmanship. The title is punctuated with a final period, which provides closure for the repeated,

rounded serifs at the bottom of the four "A"'s and the "N." It should not surprise us that Hicks was also a Quaker preacher and a painter of tavern signs.

Together, the painting and the frame allow us to experience a sense of wonder before nature and give rise to a drama of surprising power. Unable to look away from this arresting collaboration, we surrender to the rhythm of the frame's poetry, to the richness of its lettering, and to the swirling activity of the canvas they surround.

Although there are obvious similarities between these two pictures, Hawkins is as direct, bold, and intuitive as Hicks is mild and thoughtful. Hawkins has painted his frame directly on the painting surface and fused it to the image. The title is at bottom center, like a nameplate on a museum frame, painted in white with direct, unsophisticated uppercase and lowercase letters that are run together to form a single word. Below is the artist's name and birth date—regular elements in almost all of Hawkins's paintings—painted in dark red over a green of almost the same value, which makes them difficult to read. To intrigue the eye and perhaps to minimize his name in deference to the monumentality of the subject, the artist has whited in some of the empty spaces in the letter forms, creating shapes that break up the text, a reprise of the tumbling water that emanates from the spillway at the bottom of the falls.

Around the outside of the entire image is a series of boldly painted white lines—rectangular dashes—painted over a dark band. This resembles a series of film-sprocket holes but on all four edges, creating a wonderful dynamic around the perimeter. On the top row we look *through* the "holes" into the sky; on the other three sides the holes appear to be on the front of the frame band. The oscillating effect created by these marks keeps our eye active at the edge of the painting and moves us in and out of the picture, as it shunts us around the outside edge. Like Hicks but with different elements, Hawkins has ensured our continuous engagement with his painting of this American landmark through his bravura treatment of its frame.

With his characteristic mix of sophistication and naïvété, Paul Klee has created in *Ad Marginem* (literally, "at the edge") a painting about the sun as the source of life on our planet. The frame on the edge of the canvas appears to be a simple strip of plain, square-cut wood covered in loose-weave fabric suggesting a shallow window planter that is barely able to contain the wildlife and vegetation that creep along and around it, growing inward toward the sun near the center of the canvas. This 360-degree heliotropism makes it possible for any side of the frame to be used as the bottom of the picture.

Nothing comes in contact with or crosses in front of the sun in this painting. That isolated circle floats and mysteriously sucks us into the painting the same way as it attracts the plants. It also recedes into an endlessly deep central space. Part of the reason we feel the powerful pull of the sun is our conditioning to see this ultimate energy source as apart from our world. By contrast, the picture frame is totally connected to the real and the concrete, serving as our link to whatever imaginary world the artist places within it. Intellectually, the frame seems close to us, the sun far away.

Scattered among the vegetation and creatures on the frame are meticulous, lowercase, cursive letters, some taken from the painting's title. These letters are the same type as those used in diagrams and illustrations from nineteenth-century scientific treatises, and they lend a pseudo-serious air to the whimsical cast of denizens. Because we naturally want to set the letters "right" in order to read them, we are forced to rethink the top and bottom of the picture, and we twist our heads in order to view the image from all four sides. This mental repositioning of the frame and painting to see which orientation is correct plays with our predisposition to view a frame as part of our world and therefore outside the world of the picture. No matter how we hang this painting, there is no absolute right or wrong. Although the various life forms growing from the frame are purely Klee's invention, we believe in them just as children willingly believe in the world of fairy tales. This is, of course, what Klee wants us to do and is part of the cleverness and humor of the piece. His idiosyncratic flora and fauna are as rich, interesting, and alive as any we know of in our "real" world; once we accept the frame, we embrace what comes with it.

Smith, known for her quirky and thought-provoking appropriation of American pop and literary icons, has used picture frames to expand on the issues raised in her art throughout her career. She incorporates into her collages and installation pieces a miscellaneous assortment of Hollywood visual and verbal clichés, words and images from American car culture, and phrases gleaned from such iconoclastic writers as Walt Whitman, John Dos Passos, Raymond Chandler, and Jack Kerouac.

About 1980 Smith began to make frames related to the content of her pieces. She developed a personal rapport with the owner and staff of a Los Angeles frame shop and eventually began working in the shop alongside the finishers, learning the craft of making frames with specific idiosyncracies. Through this experience, she found that she could use the frames to enhance a quality or create a desired effect. As Smith wrote, "I could suddenly get a look that wasn't part of traditional picture framing—the look of found, weather-beaten objects."[1]

At this same point in her career, Smith's assistant on a number of large-scale projects was a scenic artist who had worked at CBS. From him she learned the craft of faux finishes and other scene-painting techniques—the nuts and bolts of Hollywood illusionism—and how to make representations of objects she couldn't find for her work. "I realized that the look of 'real' is a standard Hollywood set-decorating technique—where you can't tell the difference between the found and the made—and that this technology was at my disposal."[2]

Route 66, a work from 1988, is full of car-travel ephemera, but it also demonstrates the artist's mastery of the techniques of craft and composition to create a powerful visceral effect in the viewer. The lively pop-cultural elements create a stop-and-go movement all over the surface of the piece, as the eye follows visual cues from West to Midwest to South. The stomach-churning ride evokes long-ago vacations: days in the car with the road map on our laps and nights in offbeat motels. The phrase printed in red over the bottom of the map reads: "We were hot; we were going east; we were excited."

The collage is surrounded by four flat planks of wood joined together. We have seen Harnett, Klee, Eakins, and others use this solution, each manipulating that style of frame to meet the needs of the painting at hand. Smith's solution is deceptively simple, cleverly devised to correspond with life on the open road. The unfinished wood is thick and straight-cut, without even the hint of a bevel on the inside or outside edge, mimicking the directness of a roadside sign made by a do-it-yourselfer in a basement workshop.

Yet the frame is anything but obvious. The artist has created an illusion of raw wood using an uneven faux-grain treatment that produces movement around the perimeter. The dynamic top panel, which stops the viewer's eye much as signs do on the highway, clearly demonstrates the artist's skill at visual deception. The front panel thickens as it moves from left to right to produce a deepening shadow at its inside edge. In an homage to the ubiquitous, gigantic Holiday Inn marquees, Smith has shaped the top of the frame into an arrow shooting off to the right, as if encouraging us to hit the road.

1. Richard Hamilton, *Alexis Smith* (New York: Rizzoli, 1992), p. 15.

2. Ibid., p. 16.

Trophy frames have a long and rich history in Europe, where they were made in vast numbers, great variety, and often with staggering opulence. Derived from the antique practice of displaying the booty of war, trophies were a popular decorative motif during the Renaissance and later, not only in a military context featuring arms but also representing such subjects as agriculture, music, and architecture through the imaginative arrangement of appropriate tools and instruments. Trophies were carved on walls or used in other decorative ways, and frames for paintings were a natural use of the form. A hierarchy of ornamentation was created for these frames, the most elaborate designs being reserved, of course, for portraits of monarchs. Even among these royal examples, there was a pecking order of lavishness, appropriate to the recipient of the work, who might be another monarch or a lesser individual, such as a provincial governor. Portraits of European aristocrats were often surrounded by ancestral trophy frames featuring coats of arms and other family imagery.

In America the trophy frame underwent a process of democratization that found expression in frames surrounding awards for distinguished community service. During the nineteenth century, city governments frequently awarded police and fire departments with a written proclamation of gratitude for outstanding assistance during a disaster. The ornate certificate of this firemen's award has been intricately framed with a truly idiosyncratic approach that marks a stylistic high point in American vernacular framing. The frame exemplifies the retooling of old-world aristocratic forms to suit the energetic and democratic needs of the new world.

The designer has called upon the classic tabernacle frame (see Chapter 1 and Glossary), using its architectural elements. The traditional temple structure has been transformed, however, into a city building crawling with activity as firemen attack a raging blaze. The antependium at the base of the frame is an eccentric mix of openwork acanthus leaves surrounding a fireplug rather than the traditional heraldic seal. The wide ledge of the predella above the base supports a carefully rendered model of a horse-drawn water pump, which is placed directly in front of the bottom of the commemorative page.

Along each side rise Corinthian columns whose capitals support a small, double-dentate cornice that suggests the sloping roof of a porch, a design detail borrowed from typical American Greek Revival house fronts of the period. The Palladian window and the simulated brick siding add realistic touches to the tympanum/pediment, enhanced by shadows cast by the busy firemen and the dark smoke that billows from the window.

Although the elaborate relief work on this frame looks carved, its three-dimensional features are in fact crafted of compo, a form of modeling paste that had been in use for wall and ceiling ornament since the Middle Ages, replacing papier mâché and itself subsequently replaced by plaster. Introduced into woodworking shops in early-sixteenth-century Europe, as an alternative and usually cheaper method for creating raised ornamentation on furniture and frames, by the nineteenth century compo was mass-produced in molds and was widely used for stock frames, as well as for this kind of virtuoso treatment, which would have been impossible for anyone but a master carver to produce in wood.

The entire ensemble, by virtue of its realistic forms joined to traditional motifs, has an all-American energy, as it visually trumpets civic pride in city workers who have risen to the challenge of an urban disaster.

In the same tradition as the trophy frame, but totally different in spirit, is this powerful work by Horace Pippin, an untrained American artist, who surrounded his somber, monochromatic painting of a battleground with a frame that is burdened with instruments of destruction. The frame forces us to confront a group of relief objects that are both symbolic and utilitarian, representations of the armaments used in the war but not seen in the painting. We cannot view the painting without sensing the metallic, rumbling weight of the two tanks placed on the frame at the center top and bottom. We are unsettled by the helmets that face one another midway along each side; their silhouettes establish and identify the opposing armies and reinforce the palpable line of tension created by the horizontal trenches where the soldiers have confronted each other in battle. These emblems of war are placed in a discordant, aggressive array, in contrast to the triumph conveyed by the traditional trophy frame.

The crackle finish of red-orange and black paint on the simple flat panel to which the three-dimensional objects are attached exudes devastation and calls attention to the mutilated surface. Seemingly created with fire and pitch, the effect intensifies the scene by adding strong color around the dark, bleak terrain filled with staccato bomb-burst shapes, disintegrating aircraft, a flying boot in the upper right corner, and a mass of dimly outlined artillery along the bottom edge. Each tank at the top and bottom center seems propelled left by the powerful diagonals of the knife and bayoneted rifles behind it. This movement offsets the equilibrium established by the mirror-image placement of objects of war at the sides. The grenades in the lower corners are angled to force your eyes up toward the menacing images of skull-like gas masks. Without this unique frame, the artist's depiction of the horror of World War I and of mechanized warfare in general would not convey such a powerful message.

Tsunami is the ominous title of a large, deceptively beautiful paint-ing, which the artist has surrounded with a strange metal sculptural frame. The work appears to be a tranquil seascape with a bright sky full of lush, billowing cumulonimbus clouds, elegantly organized and classical to its core, a sky such as one might see in a landscape by Nicolas Poussin. However, a closer look at this familiar, even comfort-able imagery reveals disconcerting portents of ecological devastation. Gradually, we become aware that a dark shape in the luminous sky is actually acrid smoke spewing from that mountain, which is in fact a volcano; before long, an explosion and a tidal wave will threaten to overwhelm our field of vision. Our vantage point seems to be secure; we view the scene through a warship window frame of thick metal secured by heavy bolts that create a consistent rhythm around the perimeter. The opening is rectangular at the bottom and sides but arches gracefully at the top—reassuring proportions familiar to us from many landscape frames made since the seventeenth century (see Rembrandt, p. 15). A strong, slightly raised rectangular molding around the window creates a square, the most stable shape in our visual vocabulary. A similar outside molding repeats the square. The panel between these two moldings, however, is not so comforting. Its texture is in keeping with the rigors of metal, repetition, and order, but it is not metal we see. Instead, fish scales fill the panel. Thousands of them. Why are they there? We are inexplicably disturbed, and as our eye travels down the frame panel over the fish scales, we become

even more uncomfortable. Hanging from the bottom of the frame is what can only be described as a mad-scientist device: a bar attached to the frame in three places by a simple hook and screw-eye. Hanging, clamped by their tails to this bar, is a school of generic fish, solidified into the same metal as the frame. This eerie rack of dead creatures tilts the balance for us and transforms a seemingly benign painting into a vision of impending apocalypse.

5

FRAMES FOUND BY ARTISTS

Part of an artist's job description includes visual research in uncovering fresh, stimulating material to infuse a specific work and to stimulate his or her own creative development. For some artists, especially those influenced by Dada, which rejected absolutely all artistic conventions from before World War I, the junk pile is as fine a place as any to seek inspiration. Found objects, incorporated as is or slightly altered, become part of or even the whole of a work of art. The found frame has been a partner in this scavenging process for many artists, who have given it a new role that was never originally envisioned. The frames used in the portraits by Miró, Rivers, and Kahlo add a refreshing, sometimes amusing, and always engaging way of perceiving the static face of the sitter. Other examples in this chapter include frames made of found objects that have been adapted as decorative motifs or used as an integral part of the picture's content, as in the Yokoo, Saunders, and Saar.

A Victorian memorial portrait provided the impetus for Miró to demonstrate his painterly virtuosity and his ability to transform a mawkish found object into a serious reflection on the mysteries of life and death. Having participated wholeheartedly in both Surrealism and Dada, Miró never lost the fundamental spirit of either movement in his later work, and he incorporated their principles into his own style. His native Catalonia, where fantasy and rebelliousness are familiar aspects of life, also figures in his singular approach to making art. It is, therefore, no surprise that he would delight in the myriad possibilities for creative frolic offered by this once-serious, academic, and at some point discarded ensemble.

The abundantly decorated surfaces of this oversized gilt frame crawl with high-relief embellishments of blossoming vines and stylized devices: a double stem navigates the oddly shaped perimeter, dividing at each corner into spurs of spiral leaves. A cluster of Art Nouveau buds clasps the sides of each corner augmentation at the top of the frame; darker tendrils add a somber note at the lower right, reflecting the serious expression of the deceased. Two broad sashes bear the dates of the sitter's birth and death.

Miró has turned this once-serious ensemble into a whimsical interplay of spiritual elements, adding some from his own stockpile of metaphysical characters and keeping some of the vernacular religious images already in the portrait. The murky presence of the latter serves as a counterpoint to the impish quality of Miró's figures. These phantasms invade the picture through an open window made from a collaged wallpaper fragment, whose insipid roses, soaring swallow, and pale sky violate the claustrophobic solemnity of the room. A spiral motif painted on the sitter's forehead like a prankish bull's eye transforms his sober demeanor so that he now appears confused and somewhat perturbed at the appearance of these unruly characters, who propelled him into the twentieth century.

In fact, this spiral is one of several added elements that open up and invigorate the relationship between painting and frame. Centrally located on the canvas, this motif engages with the coils at the four corners of the frame and helps link them to Miró's embellishments of the painting itself. The red sun at lower left echoes the circular shape of the frame's corners and metaphorically provides the foliage with life-sustaining energy; the spidery black lines and leaf forms energize the frame's dark vine.

No longer simply a remnant of a period of cliché-ridden design, the frame has become an essential part of this revitalized portrait, which may be a symbolic depiction of the artist himself, a person full of humor and aware of the inexplicable nature of life. In transforming this picture, Miró has also changed the way we see its frame. The revised painting and the old frame are not the strange bedfellows we once thought they were but seem perfectly happy together, locked in an alliance of Dada prank and Surrealist dream.

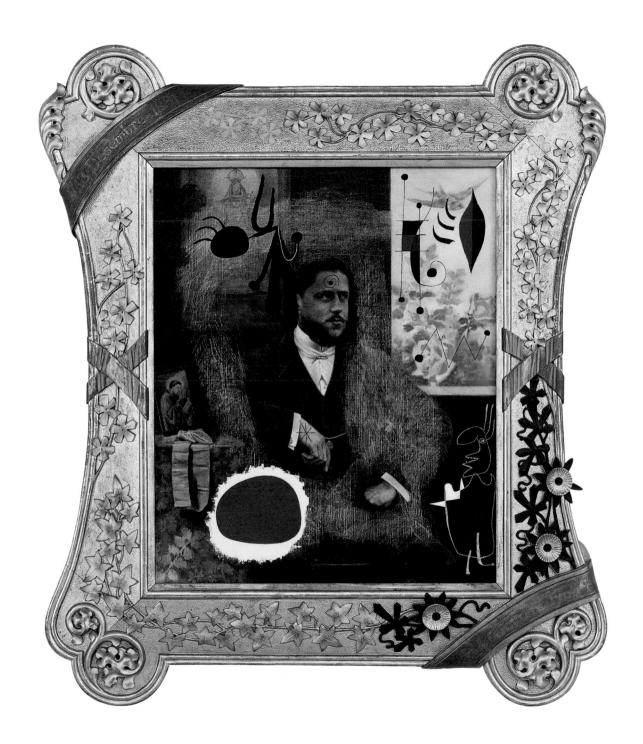

This portrait offers three works of art for the price of one, a deal rarely seen in the art world since the triptych altarpieces of the Renaissance. Larry Rivers has creatively manipulated an aluminum storm-window casing and transformed it into a portrait frame that can be viewed as a modern reprise of those elaborate earlier constructions.

Rivers and his friend Jim Dine have much in common; they are both figurative artists in a pack of abstractionists (at least they were in the 1950s and 1960s), and they both love to draw. Dine, who worked in his father's hardware store when he was a boy in Ohio, makes the tools in his pictures seem like

live creatures possessed with an inner energy, with the ability to bite, grip, snip, puncture, or cut on their own. Rivers's twitchy energy makes him a peripatetic chronicler of everyone who passes through his life, a visual diarist of the New York School right up to the present day. Family, friends, lovers, historical figures, jazz personalities, and, of course, fellow artists all show up in his drawings and paintings.

As we know, a typical storm window is constructed to function in both summer and winter: in winter, the two glass panes are closed (one of them in front of the screen), and in summer the two glass panes are doubled up, exposing

only the screen. In either season one section of the frame has a doubled partition. Using this multiple action as a device for making a wall-sized happening that actively involves the viewer, Rivers carefully composed Dine's visage in several different materials on sections of the storm window. He then drew Dine once more, this time in one of his characteristic collage drawings and fit it on a backboard the same size as the full window.

When each window panel is shifted, it becomes part of a completely transformed image, one strong enough to suffer division in half by the horizontal aluminum bar in the center and still be read as a different yet engaging portrait of the same person. One of the main pleasures of the piece is figuring out what parts of the portrait are painted (or drawn) on which movable pane and which one slides in front of which to create each of the three portraits. Rivers effectively uses this optical fiendishness to entangle us as we try to sort out the three transmuting images. We must not forget that the back panel has the pencil drawing attached to it. This part of the three-card monte trick must be revealed before you can unravel the puzzle.

The storm window transformed into picture window is a wry bit of visual punning, as well as a fitting homage to hardware stores, mechanical ingenuity, and the improvisational work of two very American artists. The aluminum storm window parodies the ubiquitous welded aluminum frame used by galleries, museums, and collectors during the 1960s.

In his constant pursuit of popular imagery from his native Japanese culture, Tadanori Yokoo appropriated cards from a traditional game called *hanafuda* as an unusual framing device for this poster. In this silk-screen print, which advertises a performance by the experimental theater group Jokyo Gekijo, Yokoo has used copies of the cards, placing them side by side and end to end to create a multifunctional border. Like many everyday items in Japanese culture, the traditional deck, even the crudely printed dime-store version reproduced here by Yokoo, is imbued with complex cultural ideas about nature.

Eventually, the game became popular among members of Yakuza (Japanese organized crime groups), and this led to its being abandoned by respectable society. However, in the mid-1960s, when this poster was published, students found no stigma attached to the game; in fact, the gangster association spiced things up, adding an underworld overtone that was edgy and immensely appealing. Yokoo's incorporation of *hanafuda* into this poster and his irreverent use of other cultural icons helped establish his reputation as an international artist of the moment affiliated with American and British Pop Art, then being embraced in Japan.

The printed border of *hanafuda*, each of which echoes the format of the poster itself, augments the poster's flagrantly antisocial content, which was to promote the radical ideas of the Jokyo Gekijo, one of several small theatrical groups that produced events similar to American happenings and performance art. In part because of Yokoo's deliberate arrangement of the cards and in part because of their small scale, the frame creates a richly textured running motif that produces its own internal rhythm beyond its visual link with the poster. Dozens of individual designs coalesce to form an integrated rectangular frame.

The poster directly challenged the use of tasteful, traditional motifs to advertise mainstream theater programs; the silhouetted nude figure with a geisha hairstyle, for example, resembles posters that were being distributed in and around Tokyo at the same time to advertise striptease shows. Traditional Japanese woodblock cartouche designs (see Hiroshige, p. 34) appear at the upper right and lower left but rather than providing information about the picture, they are used here to advertise avant-garde boutiques and salons that catered to young people. Yokoo adopted the motif of exaggerated female lips in this modern cartouche format for his later work (see Saunders, p. 88); an early example appears in the lower right of this poster, another nod to the sexuality being openly flaunted.

With its dynamic border and double-edged social commentary, this poster not only advertises a specific event, but it also serves as a testament to a turbulent period. Japanese youth were protesting their government's tacit complicity in America's growing involvement in Vietnam. The frame of *hanafuda* cards trumpets this rebellious mood and focuses awareness on the global gamesmanship of the 1960s.

Raymond Saunders is a well-known scavenger. For this drawing he raided his library and appropriated the slipcase of *The Complete Tadanori Yokoo*, which he retooled as a frame. This cardboard case, designed by Yokoo in 1970, is covered with a colored comic-strip style, all-over pattern using a motif reminiscent of George Tillyou's famous Coney Island symbol—lips around an open mouth, with the top row of teeth showing and the tongue sticking out. On the slipcase Yokoo laid out the mouth pattern in horizontal and vertical rows; Saunders flattened the slipcase and set his drawing on it so that the teeth predominate, repeated many times along the top, bottom, and left side, like a parody of the dentil carving found on classical-style frames.

Saunders's mixed-media drawing is one of his typically mischievous and puzzling images that plays hide-and-seek with the eye and mind. Flowers, birds, fruits, animals of unknown origin, and a strange Janus head occupy what appears to be a transparent, layered landscape. The precise, slender line that describes these forms (linear dexterity is a Saunders hallmark) is similar to the quality in Yokoo's motif, so that the frame and the drawing are compatible. The colored pencils used by Saunders to fill or shade the shapes are from the same palette as Yokoo's, another graphic link between the two.

Although the mouth motif is used with a mechanical regularity, Yokoo's sophisticated manipulation of color backgrounds lends his slipcase design both variety and seductiveness, tantalizing the eye as it teases our notions of symmetry and pattern. These qualities play right into Saunders's need for a frame, but he has made a subtle shift to accommodate the former cover by placing the drawing to the right of center, almost completely covering the vertical rows of full mouths. Only the slightest bit of a pink wedge, the tiny corner of a mouth, delineates each side of the drawing, like a series of fleshy punctuation marks.

The frame and drawing together delight us by exposing this byplay, as Saunders reiterates Yokoo's design device to bring visual dynamics and spontaneity to his assemblage. The original grid of lips was designed to run off the edges in all directions; before it was folded and glued, the slipcase was a rectangle that looked just as it looks now, minus the drawing. The central die-cut spine of yellow shows us exactly how much to the right Yokoo shifted the grid. The lively exchange between frame and drawing is also slightly off-kilter, enhancing both elements through the kind of savvy combination that is a specialty of Saunders'—marrying bits and pieces appropriated from sources high and low.

Frida Kahlo was obsessed with making self-portraits. In this example, her pet monkey, Fulang-Chang, has joined her in the composition, and thanks to the artist's choice of frame, we become an unwitting third party. The many angled mirror panels on the frame force on us an uneasy self-awareness as both witness to and component of the painting. Multiple refractions of our own image, repeatedly thrown back at us as we try to focus on Kahlo's uninflected expression, corner us in a kind of staring contest that we are destined to lose. Our discomfort is only intensified by the monkey's unflinching gaze, which seems to be focused on something we are wearing. Kahlo's message seems to be: Deal with me as I am, and also with my animal aspect.

The artist conceived this portrait as a traditional Mexican retablo, which usually has some mirrors in the frame overpainted with decorative motifs, but the effect of the portrait is anything but traditional. The viewer is caught up in a swirl of visual, visceral, and psychological manipulations, in a dialogue with the artist herself. Usually the artist-viewer exchange is controlled by the viewer; in this case Kahlo has the upper hand, having snagged us in a narcissistic impulse that catches us off guard. We cannot seem to extricate ourselves from this uncomfortable situation. The mirrored frame is the culprit, locking us into an unsettling encounter with Kahlo, her pet monkey, and ourselves many times over.

The simple phrase that describes the materials used in *Watching*—
"mixed media with metal frame"—conveys little sense of the true re-
lationship between frame and picture in this Betye Saar work. She
has used an early twentieth-century cast-metal grille as both cage and
frame for the young woman trapped behind it. Because the decorative
aspect of the grate is engaging and belies its coercive function, we ini-
tially respond with pleasure to its attractive design: three loops made
up of graceful curves that remind us of Islamic arabesques. But even
as it engages by its alluring pattern, the grate also makes it difficult to
see the figure. The alarming whites of the woman's eyes capture our
attention; one eye is completely visible, a drama of dark circle and
white oval that is the nexus of the work. But the remaining, darker
elements of the face are partitioned by the grillwork, which makes it
difficult to assemble a complete head.

As we go back and forth between cage and face, trying to tease out
from the design the woman's countenance and her psychological
mood, two features of the grillwork emerge: the thorny protuber-
ances, which add a menacing quality to the graceful curves, and the
asymmetry. Except for the four corner segments, the right and left
halves of the metal cover do not mirror each other. Attached to the
edge of the frame is a brightly colored tin bird, whose profile head
offers another eye to observe and be observed by. This bird does not
suggest flight; its wings hang inert at its sides, and the tail dangles
below the body. The three principal elements of this assemblage—
the bird, the grille, and the woman—are engaged in a three-way tug-
of-war that pulls us into the action.

The strange mixture of narrative portraiture, found object, and whimsical decoration evokes an enigmatic, timeless quality, yet the image of the
young woman behind the grille, amplified by the extremely compressed depth of field, is a straightforward appeal to our conscience. The frame
controls and contains the image, becoming an integral part of it.

6

FRAMES DESIGNED BY ARTISTS

Artists have often made considerable effort to control the frames surrounding their work. The Renaissance was the first fertile period when artists and artisans in various disciplines, often working together, made countless inventive contributions to the function, construction, and decoration of frames. The Michelangelo-Barile frame in Chapter 3 is a superb example of this type of collaboration, a tradition that was carried on by Gustav and Georg Klimt, Charles and Maurice Prendergast, and Jan Toorop and M. Joosstens.

In the nineteenth century Ingres was able to work within accepted decorative conventions yet invent frames that served to enhance both formal and contextual attributes in his portraits (see p. 51). More often, however, artistic control of the frame meant working against established norms. The Impressionists and Post-Impressionists, with Degas in the forefront, railed against the antiquated academic "rules" of the established salon, and their explorations of form and color led them to develop frames especially suited to their own aesthetic needs. Resistance to the salon system encouraged artists, among them Seurat and van Gogh, to reconsider their frame options. Many relied on traditional forms, with modest variations, while others relished this newfound freedom and invented radical frame solutions that were often critically attacked or dismissed as misguided. The original solutions developed by Whistler (see p. 52) and Gluck were adopted by professional framers and are still used today with the artist's names attached. Certain modern artists, including Matisse and Mondrian, were concerned with the effect of the frame on the work of art, and they relentlessly explored ways to reduce the frame's physical presence as they sought to integrate it into the work itself.

Frame profiles and studies from Degas's notebook of 1879–82

The dealer Ambroise Vollard wrote: "Degas once told me he considered it the artist's duty to see his pictures properly framed, that he wished the frame to harmonize and support his pictures."[1] Degas's sketchbooks contain various profile drawings and frame studies that attest to his concern with the presentation of his work, which he wished to be both simple and elegant. These sketches document his efforts to find a harmonious transition between the wall and the painting. Although he studied frame concepts throughout his long career, his most creative ideas coincided with the explorations being carried out by the Impressionists during the late 1870s and early 1880s. Many of the designs are reminiscent of those used by the Pre-Raphaelites in the 1860s and later developed by Whistler in the mid-1870s (see p. 54). Degas experimented with frame finishes as well as forms and used neutral tones and bright colors instead of traditional gold leaf. The gold frame we see surrounding *The Print Collector* was designed by the artist, who drew its profile in his sketchbook, and is often referred to by framers as a "pipe" molding for obvious reasons.

The assemblage of decorative paper scraps framed in the upper right corner of the painting pays homage to the influence of Asian materials that were flooding Europe at the time. Chinese and Japanese paintings were traditionally mounted on wide surrounds of colored fabric chosen to set off the work, and Degas was one of the first to combine this idea with the "box" frame currently in use. This frame was designed to display prints and drawings in which a wide mat, or passe-partout—usually colored to harmonize with the picture—surrounds the image; the protective glass cover is held in place by a thin, raised, and often grooved molding. We know that Degas favored green for his frames, which many at the time considered eccentric. Ever the acerbic critic, Whistler called these "garden frames," probably making a reference to the color of the chairs in Parisian parks. When Degas and his Impressionist contemporaries showed their works together, they invariably chose to paint the walls in tones that best complemented their paintings.

The frame for *The Print Collector* is a perfect example of Degas's belief that the frame should harmonize with and support the picture, with the exception of one crucial ingredient: color. The frame was originally painted, probably a tinted white in the manner of the Impressionists or in light tones taken from the painting. The thick, opaque gilt color we see now may have been applied when Degas decided to submit the picture for exhibition. We can only speculate about the impact that the original frame, whatever its color, had on the painting, but we can assume that the white areas in the picture would have been perceived in a profoundly different way than they are now.

1. Louise W. Havermeyer, *Sixteen to Sixty* (New York: Metropolitan Museum of Art, 1961), p. 251.

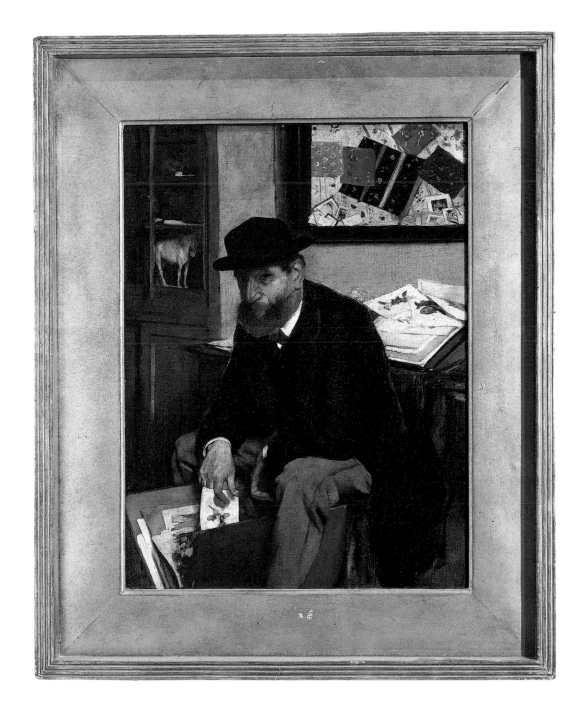

The setting of *Poseuses* (Models) is a corner of Seurat's studio, and the ostensible subject is a group of three carefully posed nude models, although it can be argued that the real subject is the artist's discourse on frames for his paintings. His mammoth masterpiece, *Sunday Afternoon on the Island of La Grand Jatte,* rests on the floor, and part of it occupies all that we can see of the wall at the left. The painting has a very broad white frame composed of simple and, to our eyes, modern-looking moldings. On closer inspection, we can see that it is an adaptation of a Renaissance cassetta frame (see glossary), with a sight-edge fillet that slopes inward from a wide, flat panel and a convex (torus) molding on the outer edge. This has a modern look to our eye, which is best explained by the convoluted development of framing tastes and styles that took place between 1850 and about 1925. Seurat's work provides a key to unlocking some of this history because he consistently experimented with the borders of his images, in many cases painting frames directly on the canvas.

Seurat saw his first Impressionist exhibition in 1879, one year after he was accepted into the École des Beaux Arts. The avant-garde paintings at this anti-academic exhibition were not all that stimulated the young painter. The galleries were hung sparsely, with no plants or drapery, unlike the typical salon exhibits, where paintings were hung close together from floor to ceiling and side to side. We have now become so accustomed to the sparsely hung art gallery that it is difficult to believe the Impressionists' presentation was revolutionary at the time. The frames chosen by the artists were radically different from traditional forms and would never have been accepted by the official salon. It must have been exhilarating for Seurat to see unusually simple frames, painted in white and gray, some even in bold colors, surrounding freshly conceived, brightly colored paintings. The highlight must have been the two paintings by Mary Cassatt, one framed in vermillion, the other in green.

Within five years, Seurat produced *Sunday Afternoon on the Island of La Grand Jatte* (1884–85) and designed a frame for it that is uniquely his, the one that he recorded in *Poseuses* three years later. (It is this painting that inspired the Art Institute of Chicago to reframe the *Grand Jatte,* reproducing the frame Seurat had designed for it, replacing a simple strip frame that had come with the bequest.) The white color was inspired by the Impressionists; the molding was of his own devising but based on a Renaissance format. There is, however, a singular element in Seurat's frame that is easily missed, given the size of the painting. At the edge, painted on the canvas, is a thin, multicolored band that acts as a bridge between the image and the frame molding; this band is not visible in *Poseuses,* suggesting that the artist added it after 1888.

On the right-hand wall of *Poseuses* are four examples of Seurat's experiments with the perfectly proportioned frame. All four pictures have flat, matlike surrounds, characteristic of his other work from this time. It is unclear whether the frames are painted on each canvas or sheet of paper or on a separate wooden support, although it is likely the latter. Three different framing approaches are shown. The two horizontal paintings at the left are the same size with matching surrounds of equal width on all sides, repeating at the frame edge exactly the proportion of the painted image. The eye is thus not distracted by any irregularity, and one can absorb both pictures together at very close range because the surrounds are relatively narrow. The vertical image in the middle is the largest of the group. Its frame is equal in width on the top and sides but the bottom is wider, which adds visual weight to the base of the work. It also physically extends and therefore reinforces the vertical character of the piece. The fourth painting, on the right, is a square but the frame is not. A square is a notoriously difficult shape on which to paint satisfying images, either figurative or abstract; the bottom edge of the frame is

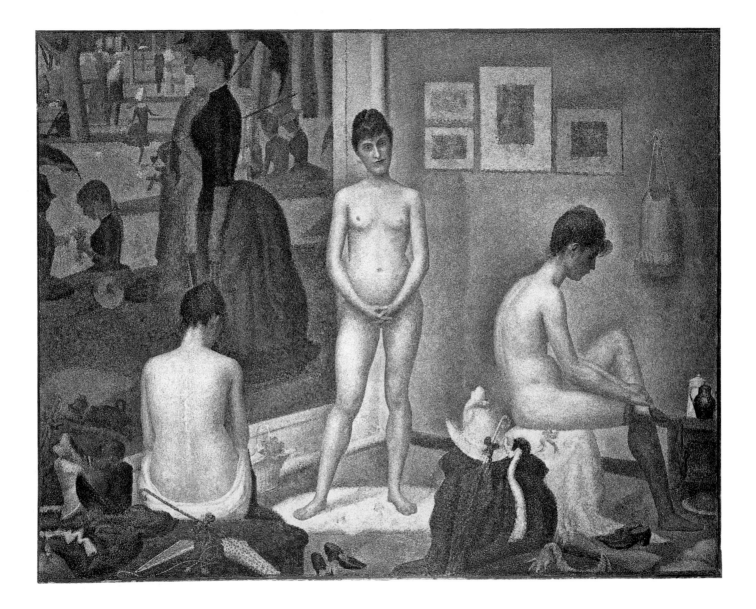

slightly wider than the top and sides, as in the vertical painting, and this throws the square comfortably off balance and diffuses its centralizing power.

The four pictures when viewed as a unit are like a ballet of weights and proportions, an array of design possibilities that clearly intrigued the artist. Although many would see the grouped paintings as counterparts of the three posed models, a case might be made that Seurat used the nudes as an enticement to view his exposition of frames hung on the wall behind them.

Gustav Klimt's sketches for the frame
of *Judith I*

"It has finally been understood that picture and frame must become one again."[1] A critic published this remark in the magazine *Deutsche Kunst und Decoration* (German Art and Decoration) after the first Vienna Secession exhibition in 1898. The Secessionist group, like the Salon des Indépendants in Paris and Les XX in Belgium, was unified in purpose—to divorce itself from the academy. In addition, Vienna would be exposed to contemporary European art. The Secessionists took on their mission with gusto, integrity, and strong financial backing from enthusiastic patrons. During the period leading up to World War I, Vienna was a virtual cauldron of creativity, in which all the arts and crafts were mixed together and fueled by politics, history, and philosophy. The search for utopian harmony, the striving for the total work of art, was supported by a wealthy, insular society and led to many alliances and hybrid endeavors.

A typical production of this unique climate was the collaboration of the brothers Gustav and Georg Klimt, whose father was a goldsmith. Gustav was one of the artists who participated in the first Secessionist exhibition, which was organized in protest against the dreary shows at the Künstlerhaus. He was already well known as a designer and a painter of highly stylized historical murals using gold leaf, marble, glass, and semiprecious stones. He painted elegant, contemporary interpretations of Symbolist subjects (Philosophy, Medicine, Jurisprudence, etc.), adapting styles as varied as ancient Egyptian and Florentine Renaissance to fit the needs of his commissions. By 1898, Gustav Klimt was in the process of shifting his career from mural designer to avant-garde allegorist of the human condition, reflecting the erotic undercurrents that were being investigated by Sigmund Freud and others. Gustav's brother, Georg, was an established metal sculptor, engraver, and designer who fulfilled commissions for major architects. He was responsible for the bronze doors on the controversial Secession building in Vienna, which he executed after the designs of the celebrated Viennese designer-architect Joseph Maria Olbrich, as well as a variety of smaller projects, among them hand-wrought metal frames.

Gustav Klimt's painting *Judith I* was conceived as a frame-and-painting unit, documented by a sketchbook that contains numerous studies of the picture with an integrated surrounding frame, as well as studies of individual frame motifs, such as the button rosette, spiral, wave, and the highly stylized title. These design motifs were already in Gustav's repertoire, and variations of them were in use throughout the community of Viennese artists, motifs that would later be labeled Jugendstil (young style), which featured sinuous natural forms in an imposed repetitive order that distinguishes it from the prevalent Art Nouveau style.

In *Judith*, Gustav's characteristic gold-leafed patterns embrace the voluptuous female figure, with an interplay of sensual illusionist paint surface and flat, richly worked gold designs creating a hedonistic sensuality. The frame, with its soft, slender profile shaped from warm-toned wood, is as sensual as the painting. The top third of the frame is sheathed in copper, which has been rounded over the edges and tacked to the back. Low-relief waves move up the sides to end in rows of spirals. The copper has been heightened with gold powder, suggesting the alchemist's quest to change base metals into gold and creating an unusually exotic reflective surface. The painting's title is embossed across the wide top. The relief lettering is razor thin and attenuated, derived from the hand-lettered Jugendstil graphic material that was flooding Vienna at this time on posters, books, postcards, and other ephemera. The title, difficult to read because of the reflections of light on the linear pattern of each letter, is more of a cohesive decorative passage than a distracting element.

The top third of the frame, opulently decorated like a Byzantine icon, echoes the top of the painting itself, which is dominated by tropical plant forms and a jewel-encrusted choker that effectively severs the head of Judith from her shoulders as it forms the background and foreground. Luminous wood surrounds the erotically charged torso, enhancing the sensual, luxurious mood of the painting. Pockets of darkness compress the space and create a claustrophobic atmosphere. Within one of these dark passages, unnoticed until we recognize the subject of the painting, lie the left eye of Holofernes and half of his severed head.

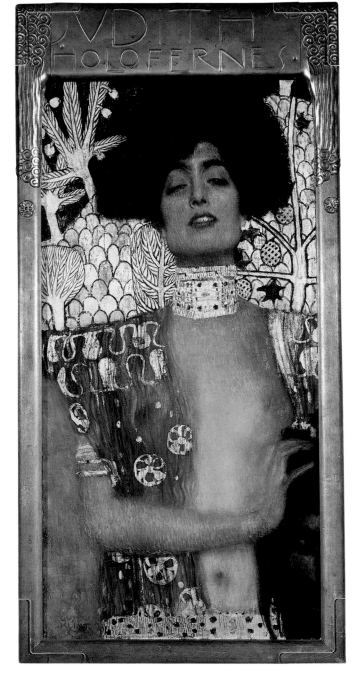

1. Christian Nebehay, *Gustav Klimt: Das Skizzenbuch aus dem Besitz von Sonja Knips* (Vienna 1987), p. 164, fig. 58.

Recounting how she came to develop the frame style that bears her name, Hannah Gluck said: "One day feeling quite despairing I took a lump of plasticine and started trying to make something very simple which, if possible, could be part of any wall on which it might be placed, and in doing this I suddenly realized that what has now become the Gluck frame was the only solution."[1] Her solution was a triple-stepped frame consisting of three wooden rectangles attached one on top of the other, with the widest and thinnest panel set against the wall and the narrowest and deepest close to the painting. This ensemble creates a gradual transition between wall and picture plane.

The debut of this frame, which she patented, occurred in Gluck's 1932 exhibition at the Fine Arts Society in London (opposite). Clearly, she was inspired by the Impressionist installations supervised by Degas, as well as by the Vienna and Munich Secessionist shows, which were chronicled in great detail as to lighting, wall colors, and hanging arrangements; a Gustav Klimt exhibition produced in 1908 by designer Josef Hoffmann; and Whistler's innovative use of both frames and wall space. Gluck hung both large and small paintings on the same walls with great elegance, often placing the smaller pictures one above another. The portraits, landscapes, and still lifes were clearly visible and accessible and were granted an independence rarely seen in exhibitions of the day.

Gluck used pilasters that rose from the baseboard to just below the top of the display wall in the same three-step system as her frames. This architectural device effectively modulated the walls into bracketed units that contained single large canvases or as many as four smaller pictures. A note in the catalogue to her 1937 exhibition at the Fine Arts Society reads: "The essential feature of the Gluck frame is that it becomes part of any wall, whatever its character, color or period It can be painted the same color as the wall, or covered with the same wall paper, or made in any wall material."[2]

The Rowley Gallery in London, well known for its display of decorative arts, made frames for Gluck's painting, including her self-portrait of 1942. In an advertisement in the March 1934 issue of *The Artist,* the magazine's editor touted the gallery as "not mere frame makers, rather frame creators." Interestingly, the white "Whistler" frame made by Rowley was chosen by Gluck in the 1940s for her smaller pictures, as in this self-portrait, in preference to the "Gluck" frame.

Degas was active in organizing the look of the Impressionist exhibitions in the late 1870s and early 1880s. Sixty years later Gluck was carrying forward the same, inexhaustible investigation of how art can be presented to the public for maximum aesthetic resonance.

1. Jacob Simon, *The Art of the Picture Frame: Artists, Patrons and the Framing of Portraits in Britain* (London: National Portrait Gallery Publications, 1996), p. 108.

2. Diana Souhami, *Gluck 1895–1978.* (London: Weidenfeld & Nicolson, 1988), pp. 102–11.

In 1938 critic Walter Pach wrote: "At Mrs. Jack Gardner's Venetian palace on the Fenway, in Boston, many a frame that looks as if it had never been touched since it left some Renaissance *bottega* owes its live forms to the Prendergast chisels and its burnishing and tone to the gilding tools of those Yankee craftsmen."[1]

The Prendergast brothers, Maurice and Charles, were the high-wire act of American framing at the turn of the century. Maurice was the elder brother, an artist known for his watercolors, paintings, and monotypes; Charles, five years his junior, was a craftsman who eventually became an artist as well. They owed much of their early success to their collaboration in the business of making innovative picture frames in the Boston area. The family was poor, and Maurice was apprenticed at an early age to a calligrapher of display signs for store windows. By the time he was twenty-seven, he had saved $1,000, which he used to pay for a three-year stay in Paris, where he was exposed to European art and was particularly attracted to

Maurice Prendergast's letter to his brother, June 13, 1907

Impressionism and paintings by the Nabis group. He developed a strong sense of color and design in his paintings and perfected the technique of applying strokes of color next to one another like mosaic tesserae. Back in Boston, he was unable to sell his pictures, and he returned to sign painting, keeping his art alive on weekends painting scenes at the local beaches, parks, and promenades.

During the time Maurice was in Paris, Charles steadily developed his craft as a frame-maker, a career that would ultimately provide both brothers with a good living as well as a loyal clientele. In 1903, Charles established a cooperative frame-making business with Herman Dudley Murphy, an American artist who had just returned from England inspired by the Arts and Crafts Movement. Their intention was to bring to artists and their work a revitalized sense of integrity, offering contemporary frames based on traditional Italian designs and techniques. Charles occasionally asked Maurice to assist him in the design of certain frames, and the complementary nature of their skills enabled them to make a significant contribution to the frame business.

They both studied period frames, particularly the Italian masters, and traveled to Europe to make first-hand observations. Maurice, who traveled more frequently than Charles, sent back many letters containing drawings and notes about finishes, gilding styles, and carving techniques. For example, a wonderfully articulate sketch included in a letter from Paris dated June 13, 1907, shows both the profile and the carved surface of a basic cassetta molding with three different motifs—a tulip shape on the inside, a repeating perpendicular arabesque along the panel, and a bar and double bead carving on the outside raised portion. Although Italian Renaissance frames were favored by the Prendergasts, they did not neglect other European styles.

The collaboration of the two brothers is well represented in the

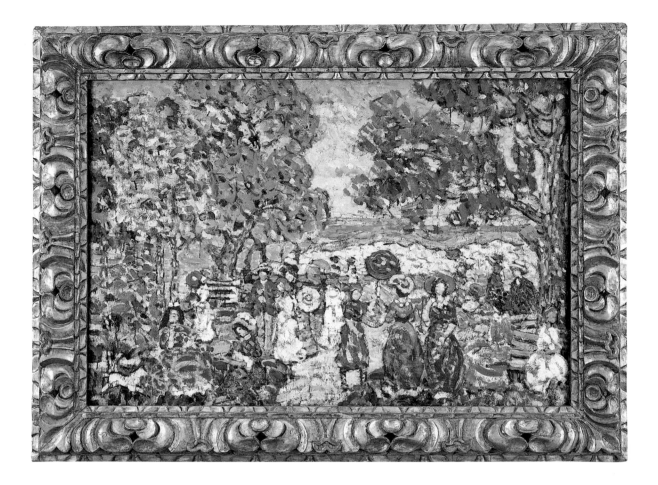

frame Charles made for Maurice's painting *Landscape with Figures.* This is a splendid example of a harmonious relationship between frame and picture. Carved in typically robust Spanish Baroque style, the design is pure Prendergast (compare with the Velázquez frame on p. 46). Charles has incorporated both French and Spanish leaf forms, which are appropriate to the picture's setting, into a unique design with four bands of motifs, each of which is masterfully carved. Although they appear the same, the side-panel carvings are considerably smaller than those on the top and bottom of the frame. At the end of each panel is a composition of a stem with leaves that nicely turns the corner without breaking the rhythm. The panels reinforce the composition of Maurice's painting, whose brushstrokes delineating trees, women's hats, open parasols, billowing clouds, and bustling skirts maintain the same energy as Charles's dexterous chisel. The sparkling sunlight of the painting is matched by the gilding of the frame, which like its Spanish models consists of a rich gold leaf laid over natural red clay (bole) and burnished to a warm luster.

The Prendergast partnership bears eloquent testimony to Yankee industry, creativity, and independent thought, as well as to the idealistic willingness of artists at this time to combat the mechanistic materialism that was threatening to eradicate the craftsman from the marketplace.

1. Walter Pach. *Queer Thing Painting: Forty Years in the World of Art* (New York: Harper and Row, 1938), p. 227.

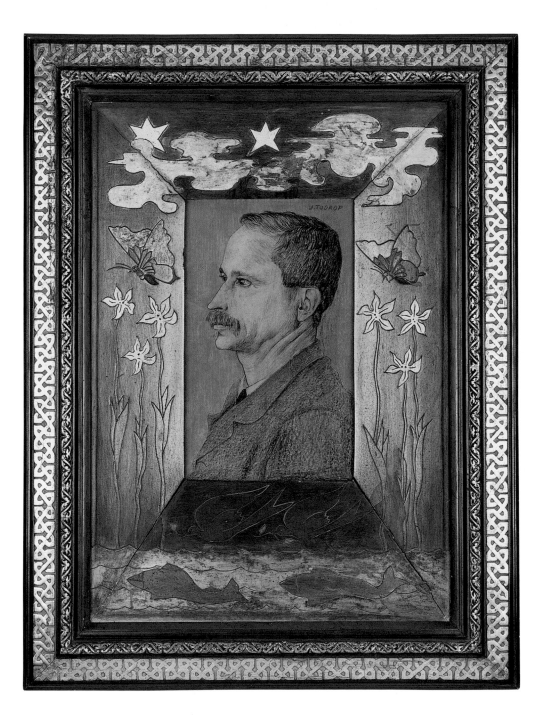

Jan Toorop, who was born in Java and moved to Holland in 1872 at the age of fourteen, divided his time in the 1880s between London—where he saw exhibitions mounted by Whistler and works by the Pre-Raphaelites and Aubrey Beardsley—and Brussels, where he began showing in 1885 with Les XX, an association of avant-garde artists. Of course, Paris was not far from Brussels, and it is likely that Toorop visited the Post-Impressionist exhibitions held during this time. The Brussels group was a very active one and gave annual exhibitions of its members' work to which they invited other like-minded European artists to participate, among them Seurat and Toulouse-Lautrec. Influential critics in the Antwerp and Brussels press championed these innovative exhibitions and also supported individual members by giving their work positive reviews. The members of Les XX were united in their approach to the display of their work in the latest anti-salon mode, and they were well aware of the art scene in Paris and of Whistler's innovations in London, either through visits to those cities or by reading the art journals that supported new ideas in framing and installation.

Although united in its desire to use the most up-to-date methods of display, the group was divided aesthetically between those who adhered to the concepts of painted frames initiated by Seurat and those, like Toorop, who followed the Symbolists and their interest in the decorative aspects of frames as extensions of the pictures they enclosed. Toorop became the most distinctive stylist in the group. He developed a unique blend of elongated, androgynous, figural imagery, which may have derived from Javanese shadow puppets, and his own adaptation of Art Nouveau, which affected virtually all the arts in Europe at the turn of the twentieth century.

Strongly decorative in design with an emphasis on a shallow, almost flat, pictorial space, Toorop's work accentuated linear quality by eliminating shadows cast by a specific source of light and by filling areas between lines with pale, muted tones, which give his compositions a moody, ethereal quality. At first, Toorop displayed his work in simple white frames, following the lead of Whistler and the Impressionists, but he quickly began to expand his images until they overflowed directly onto the wide surrounding wooden mat area; he would incise the lines into the surface and continue the picture's palette onto the wooden mat. He carefully composed stylized details of natural forms—such as flowers, animals, the sea, and cloud formations—in the mat around this portrait, in order to achieve a harmonious overall design.

Toorop befriended a frame-maker in The Hague named M. Joosstens, who produced frames based on the artist's unique designs. This portrait of Joosstens is a superb example of the collaboration between artist and artisan, an association reminiscent of those forged in the Renaissance. Surrounding the spectacular mat is a frame divided into three concentric rectangles. The inner, beveled, dark-walnut molding is the narrowest and simplest of the three; around this is a narrow cassetta panel containing a top-gilded leaf pattern in low relief, and the outside molding is a wider cassetta with a carved, interlocking pattern enhanced by a pale green background that sets off the gold ornament. The complete ensemble pays homage to the importance both men attributed to the frame and its functions.

"The four sides of a frame are among the most important parts of a picture. A painting or a drawing included in a given space ought, therefore, to be in perfect harmony with the frame . . . "[1] This comment of Matisse's is brilliantly embodied in *The Red Studio*, in which the elements of an artist's studio have been loosely painted but carefully arranged. So perfectly structured is the composition that the room feels at once spare, full, serene, and cluttered. The objects depicted in the studio were either made by Matisse (paintings and sculptures) or chosen by him (plates, vases, furniture, and picture frames) and placed in a red medium that offers us an encapsulated moment in his career set in a dreamlike space. Reinforcing the sense of fantasy and timelessness is the outline of a grandfather clock framing a numbered face that has no hands.

One of the most pleasurable ways to experience this painting is to focus on the numerous relationships between frames and pictures. There are frames without paintings and paintings without frames, as well as framed paintings. There are backs of paintings, in which the stretcher bars frame blank canvas, and pieces of furniture reduced to framelike outlines. The top unit of a ladderback chair in the right foreground, for example, frames the plate on a table, a witty variation on the grandfather clock motif. Matisse's studio is a place where many of the paintings have not been prepared for public viewing. At the left we see the painting of a large nude with a painted Islamic-inspired border, a picture destroyed after 1911, a fact that contributes to the unique nature of our studio visit. The power of *The Red Studio* is that it convinces us we are observing the creative process at first hand.

The empty frame to the left of the clock is a key element in this painting's discourse on framing. Ornate and alone, it begs two questions: How should this older style of frame function in the twentieth century, if at all, and, if not, what is needed for the new, groundbreaking pictures Matisse is making? The artist is challenging the frame's previous role as a decorative arts object, where it often related more to the style of the room than that of the painting. Also implied here is the question: What frame is needed for *The Red Studio*? Matisse's answer: none.

Any visually dominant external frame on this picture would deny the gravity-defying quality of the room and its elements, the sense of an expanding and limitless environment. A frame would pin the picture to the wall, disavowing its capacity to mesmerize and reminding the viewer of the limits. The artist has provided no internal map to guide us through the picture; we may start anywhere and wander at will from one area to another, an experience that will be different each time we revisit the painting. The separate elements remain isolated from each other; the unity of the picture is the result of a cumulative visual experience, which changes each time we explore the picture.

The Red Studio speaks to many issues, one of the most significant being the function of a frame in relation to twentieth-century paintings. The lack of a decorative frame on the painting shows Matisse's ferocious intelligence at work. Even though it is a move contradictory to his earlier statement, a pivotal self-confidence has been exercised, and, in this case, the lack of a frame is an important part of the picture.

1. Henri Matisse, "Temoignage," in Dominique Fourcade, ed., *Ecrits et propos sur l'art* (Paris: Hermann, 1972), p. 196.

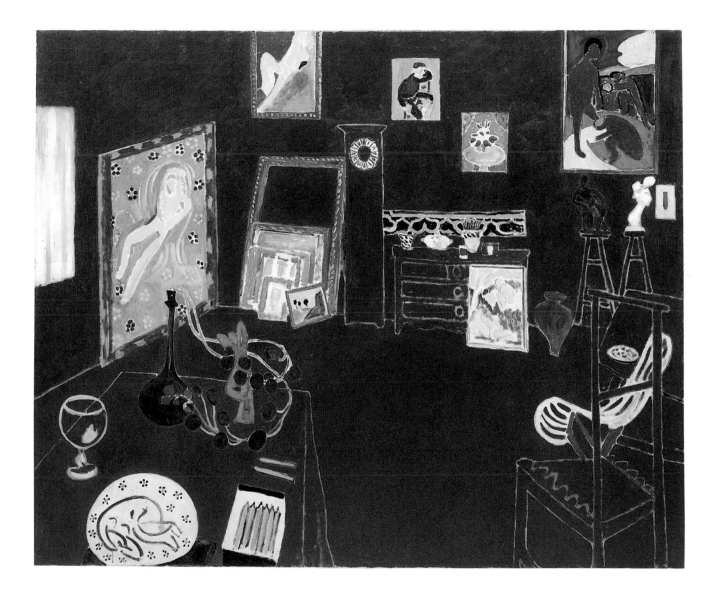

In 1943, near the end of his life, Piet Mondrian wrote: "So far as I know, I was the first to bring the painting forward from the frame, rather than set it within the frame. I had noted that a picture without a frame works better than a framed one, and that the framing causes sensations of three dimensions. It gives an illusion of depth, so I took a frame of plain wood and mounted my picture on it. In this way I brought it to a more real existence To move the painting into our surroundings and give it real existence has been my ideal since I came to abstract painting."[1]

Mondrian's long search for a solution to the problem of framing his pictures paralleled his obsessive quest for a "pure" painting style. When he first began to exhibit his pictures, he rejected the typical salon-style gilt frames and adopted a thin, flat-topped molding attached to the outside of a flat wooden mat. These frames were often painted a neutral bronze, but sometimes white or gray.

A page from Mondrian's sketchbook, 1928

By 1914, he no longer overlapped the canvas in every case but instead used thin, bronze-colored strip frames on a number of pictures, some flush to the surface of the painting and others set back from the painted surface. This latter construction exposed the wrapped-around edge of canvas but covered the nails used to attach the canvas to the bar. In 1916, he made a major breakthrough when he developed a sub-frame, a wide platform fastened to the back of the stretcher bars and hung flush to the wall. This frame both supported the painting and physically projected the painted surface away from the wall (for a variation on this idea, see Gluck, p. 99).

In 1920, Mondrian wrote from Paris to a friend: "without a frame they look the best."[2] He sent four paintings unframed to an exhibition in Rotterdam that same year because he wanted them hung that way. Collectors and critics objected, however ("They are too bald," one friend wrote to him). Reconsidering his position, Mondrian returned to the idea of a subframe. In a 1921 letter to the architect J. J. P. Oud, Mondrian included sketches of frames showing a set-back wooden strip (see illustration). Over the next twenty-eight years Mondrian devoted himself to solving the relationship between his pictures and their environment.

Mondrian's dealer in New York, F. Valentine Dudensing, sold *Composition B* to the American collector Albert E. Gallatin, who immediately exhibited it along with six other Mondrians in his newly named Museum of Living Art. A close look at this frame reveals the full range of devices that Mondrian used to create delicate extensions of a painting while ensuring its safety. The use of two set-back strips, seen here, is rare in Mondrian's work. The inner unit is crosscut horizontally, and the outer unit is crosscut vertically, but each is the same width, so that the combination creates a double-wide face, wider than the thickest black lines in the painting. The way in which the strips are cut bears a subtle, architectural relationship to the composition of the painting. At the top, for example, the horizontal crosscut creates a post-and-lintel effect, which gives a sense of solidity to the frame. These inner strips contrast with the three vertical black lines, expanding by repetition our perception of the painting's width. The white subframe that lies behind and surrounds the strips recapitulates the balanced arrangement of elements in the painting itself.

The frame on this work is a prime example of how Mondrian manipulated variants within the narrow range of options he had devised, just as in his paintings, where he was able to create an infinite world of diversity with fundamental elements that he manipulated with intuitive, subtle, and dynamic shifts from one painting to the next. There is a sense of play, for the pleasure of experimenting, discovering with each new painting a way to extend its rhythms and its harmony beyond the painted surface out into the surrounding environment and ultimately into the utopian world he believed could be created through art.

1. "Eleven Europeans in America," *The MoMA Bulletin* 13 (1946), no. 45, pp. 35–36.
2. Yves-Alain Bois, *Piet Mondrian* (New York: Leonardo Arte, 1994), p. 172.

Salvador Dalí, the Surrealist painter well known for his psychologically charged, metaphorical landscapes, found a way in this double portrait to exploit picture frames to suit his own needs by giving them human contours. The artist has surrounded segments of a vast seascape with a gilded cassetta molding and a textured panel that he has formed into bust-length silhouettes of a man and a woman conversing, or perhaps conspiring. The frames are an integral part of the work, provoking us to view the seascape as the internal world of the couple, a shared terrain filled with the enigmatic images conjured by the artist, rather than an ideal world perceived through a rectangular frame.

Dalí's integration of the frame into his illusionistic painting is an early example of the modernist rejection of the traditional window format; however, his frame does honor tradition by establishing a fixed boundary between the viewer and the realm of the painting. What Dalí has accomplished is to alter our perception of that realm by changing the shape of the frame. This trickery is evident in the way he has forced us to see the seascape as an endlessly expanding imaginary panorama beyond the frames; we are compelled to fill in the missing links. The horizon and the tabletops line up to carry our eye across the empty space between the couple, linking them together psychologically, affirming their shared existence.

So convincing is the integration of frame and painting that at first we do not notice the tilted clouds in the man's nodding head. Only after a moment do we become aware that the anthropomorphic frame has been granted the power to manipulate the sky.

The thoughtful selection of frame components chosen by Jasper Johns to surround *Dancers on a Plane* reveals a concern with presentation reminiscent of both Degas and Whistler. Johns's knowledge of the frame-maker's craft is revealed in a set of instructions written to a framer in the early 1970s, in which even a simple-looking frame is clearly the result of careful consideration, not only of the molding but also of the type and finish of wood and the subtle tones of the silk or rag board for the mat.

Dancers on a Plane is dedicated to the dancer and choreographer Merce Cunningham, with whom Johns has frequently collaborated. The painting itself, although inseparable from its frame, presents us with a space not unlike the stage in a Cunningham dance—an area alive in every particular and utterly engaging as a whole. Here, as in Cunningham's choreography, a palpable and disciplined energy quietly but firmly occupies the space, making it accessible rather than spectacular. With its pattern of lines that track everywhere on the canvas, the painting shares with a Cunningham dance a kind of cautious vitality, as well as an aura of extraordinary animal intelligence that defies explanation.

Along the canvas base, just above the frame, Merce Cunningham's name is stenciled in black; the "M" in Merce starts left of center and moves, conventionally, toward the right. The "I" of his last name meets the frame at the right sight edge; the name reappears at the left edge of the canvas with the double "N"s and continues to the center. These letters alternate with the colored letters of the painting's title, which are stenciled in reverse and read from right to left. After a struggle, we realize that the words are arranged so that they would meet if the canvas were rolled into a tube whose circumference allows the sides of the painting to abut each other. Also the crosshatch motifs would line up and join together.

This row of letters presents a visual conundrum that has long interested Johns: the idea that painting, by its very nature, shows only one face; the back is never revealed. In order to sort out the words, we must envision both sides of the painting, which become more transparent as we work out the puzzle. In fact, if we were to look at the back of the canvas, we would read the title of the painting "correctly" and Cunningham's name would be spelled in reverse. The frame's function in this exercise is twofold: it holds the painting taut in order to maintain the flatness of the surface; at the same time, its post-and-lintel structure suggests a portal that grants access to the other side of the canvas, now perceived as a scrim.

The frame is composed of cast-bronze Tantric symbols and replicas of kitchen utensils—knives, forks, and spoons. It is not surprising to find kitchen tableware in a Johns piece, nor is this the first occurrence; eating utensils are part of a large inventory of ordinary objects, including light bulbs, flashlights,

Framing instructions from the artist

and ale cans, that Johns has appropriated and developed into his own expressive vocabulary. Commonplace objects are so familiar that they have become virtually invisible to us, and drained of content; it is precisely their neutralization that Johns takes advantage of, visually revitalizing them and making us see them in the context of his own complex iconography.

When asked about the knife, fork, and spoon in another work, Johns responded: "My associations, if you want them, are cutting, measuring, mixing, blending, consuming—creation and destruction moderated by ritualized manners."[1] But what of the sexual imagery at the top and bottom of this frame? Johns has said of this frame that it "brackets the painting with symbols of creation and destruction, principles which are central in the Tibetan works."[2] We do not usually associate creation, destruction, and Tibetan art with tableware, but Johns does not make usual associations. The relief image of scrotum at bottom center, and the penile shaft set in a triangle directly above it along the top, refer to seventeenth-century Tantric paintings, which Johns was studying at the time

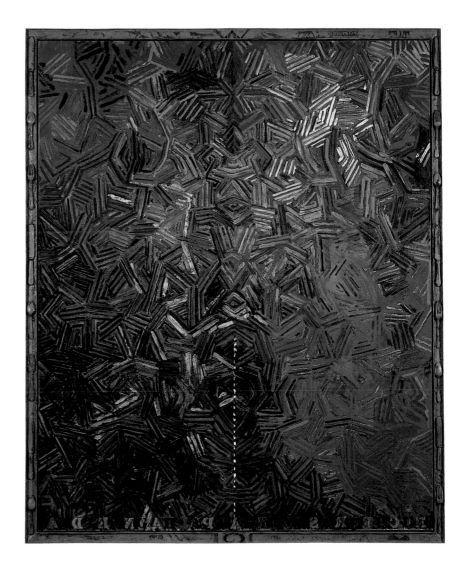

this work was made. The blue and green scrotum derives from a startling masterpiece, *The Terrible Devata Samvara*,[3] in which the destructive and creative aspects of the god are depicted, including the god's many hands holding swords, knives, and other weapons, which Johns has transposed into kitchen utensils on his frame.

As Whistler has done several times, Johns uses the frame, not the painting, for identifying authorship, inscribing J. Johns in the bronze cast at bottom right, a final gesture that makes the frame and painting inseparable.

1. Nan Rosenthal and Ruth Fine, *The Drawings of Jasper Johns*, exh. cat. (Washington, D.C.: National Gallery of Art, 1990), pp. 81–82.

2. Tate Gallery, *Illustrated Catalog of Acquisitions 1980–82* (London: Tate Gallery, 1982), p. 146.

3. Ajit Mookerjee, *Tantric Art* (Basel: Kumar Gallery, 1971), pl. 9, p. 30.

7

FRAMES MADE BY ARTISTS

The complete integration of the work of art with its frame is almost always the result of the artist's having made both elements. Sometimes artists have produced their frames out of necessity, as in the trompe-l'oeil frames of Field and Harnett painted directly on the canvas to save the expense of a real frame. Frames by artists can also be an integral part of the formal structure and content of the work, a part of the premise for the existence of a piece, without which the remaining elements would simply disintegrate (see Calder). In some instances, removal of the frame would disrupt the complexity of the painted surface and destroy the aesthetic unity of the piece or even diminish its meaning, as we have seen in Hodgkin (p. 38) and Johns (p. 110) and as is exemplified in this chapter by Dalí and Nutt.

Even in the absence of a constructed frame, most artists are aware of the role or "idea" of the frame and accept the presence of a framing edge at the end of the canvas surface. Awareness of how this edge relates to the wall has resulted in refreshing approaches to presentation, seen here in Stella and Gelfman, sometimes provoking new questions about the frame, its function, and even its very existence.

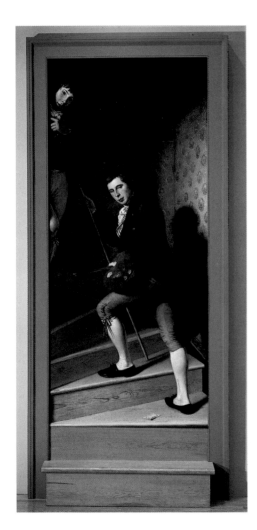

When George Washington visited Charles Willson Peale's museum in Philadelphia, the story goes, he walked past a staircase that entered through a side wall, and without breaking stride he tipped his hat to the two young men, Peale's sons, discreetly peering out at the visiting president. If the story is true, the painter must have swelled with pride at the effectiveness of his handiwork. The father of his country had tipped his hat not to Peale's sons but to Peale's painting! Peale was the most ambitious and accomplished of all American trompe-l'oeil painters. He managed to carry illusionism beyond mere persuasion to what many considered outright brainwashing, and he was able to do so beyond the scale and restrictions of still-life painting, the genre to which his closest rivals remained loyal.

One of the major reasons Peale was able to pull off his hoax in this life-sized painting (which is nearly eight feet high) was that he ingeniously placed at the bottom of the painting a three-dimensional wooden step that extends into the room. He then perfectly matched the tone and grain of this wood when he painted the stairs that spiral upward into deep shadow, disappearing out of sight into the picture.

The illusion is furthered by a typical colonial-style doorway molding, painted a vibrant blue, which surrounds the top and sides of the painting. The molding nestles behind the protruding bottom step and descends flush to the floor, a common architectural device of the time, so common that it would never dawn on a passerby to question its authenticity.

Peale was an artist of remarkable skill, able to capture with brush and paint on canvas the likeness of anything in the material world, but in this group portrait, it is the framing ruse of doorway and step that allows us to be hoodwinked by his visual trickery. It assures us that everything within the door is unimpeachable. The cues are here, and our eye-mind mechanism picks up on them. We are as convinced as Washington was that the Peale boys are heading up the stairs. A tip of the hat is well deserved.

When it comes to the look and function of a frame, William Harnett and Paul Klee (see p. 71) shared a similar idea: make the frame simple and then fill the painting with the entire world. Harnett's world is not Klee's, full of fantasy and diagrams, but one that is utterly grounded in concrete reality. As such, it demands our collaboration in order to deliver on its promise.

We have seen, touched, or used most of the items we see in Harnett's painting. We know what these objects are made of, and we have a sense of their texture and weight, and yet we willingly permit the artist to toy with what we know by allowing us to deny our absolute knowledge that these items are flat renderings, painted on a surface. We know that if we reach out and touch them, they won't be there; Harnett's skillful execution of this deception charms us into accepting what we know is not true.

We are doubly impressed by the artist's cool technical control when we consider that one false note of shadow, one miscalculated highlight, will ruin the impression that all is correct and secure, that we are witnessing an aspect of the world exactly as we know it. Bearing in mind the artist's confidence in his ability to depict the complex objects within, we must concede that the most important factor in the deception is one of the simplest in the painting: the frame. We are not to suspect for a moment that the frame is anything other than a slightly battered, carefully hewn piece of real wood set slightly in front of the barn siding on which the items are hung. If we let doubt creep in, our credulity, and his credibility, will vanish. The entire house of cards will fall apart in front of us. We tacitly agree not to spoil the fun so we may continue to relish Harnett's skillful deceptions and abandon ourselves to a reality of illusion.

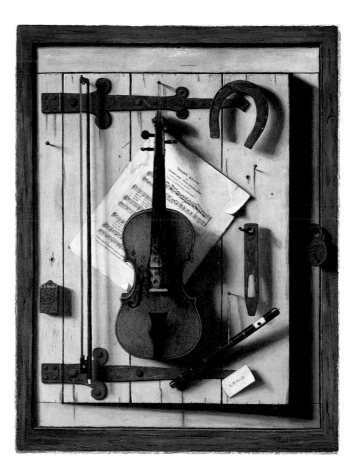

This is a superb example of a simple but compelling trompe-l'oeil frame. It was, almost certainly, painted to save the cost of an expensive three-dimensional one, a common practice among naïve American artists of Field's time. It is a challenge to look at the rectangular surface of this picture and not feel that there are two distinct elements present: a colorful, boxlike frame and a mysterious painting of the idyllic garden. Only after considerable mental effort do we concede that the enigmatic image of Eden exists on the same flat canvas as its vibrant enclosure. The artist has, of course, performed various tricks to exploit our visual perception in order to convince us that the frame and the image are two separate entities.

One device he has used for this deception is to shade the top and right sides of the fake frame, creating a sense of external light from a source in front falling on a three-dimensional shadow box. This "light" illuminates the inside of the frame along the bottom and the left-hand side. A simple device but enough to confound our perceptual apparatus, conditioned as we are to register light and shadow as markers of actual depth.

Perhaps the most persuasive detail of the shadow-box illusion is provided by Field's skillful use of contrast. The bold, almost strident light illuminating the frame is in stark contrast to the soft luminosity that pervades the garden. These two kinds of light help convince us that we are seeing two different components, each lit from its own source. Colors also have a powerful effect on how we interpret what we are looking at here. The bright blue-and-gold-decorated rectangles, reminiscent of the backs of playing cards, stand out against the atmospheric landscape, which is partially enshrouded in mist, to create a strong distinction between the border and the illusion of paradise.

Field's frame for this painting is an example of one-point perspective, in which all the straight lines lead along the frame toward a point near the exact center of the picture. We have experienced this device so often that we fall for the illusion unconsciously, and Field reinforces this suggestion of depth by introducing some clever details. He subtly calls attention to the corners of the frame, where the gold bands abut, by inserting a thin line to represent what appears to be a mitered joint. This innocent suggestion effectively leads our eye back into the painting, reinforcing the illusion of perspective.

Field has also used a thin black line between the painting and the frame to make a strong demarcation at the edge of the landscape, forcing a perception of distance. An outside border of dark brown adds an illusion of thickness, so we are convinced that the frame has been made from a piece of old wood and our eye obediently vaults over this "fence" of a frame and into the painting. Another mechanism that helps the landscape and frame to separate is the cropping of vegetation and animals in the landscape foreground. We cannot see where the large, lush plants or the horses and oxen touch the ground, which gives us the sensation of sitting in a chair and looking out on the scene through a window.

Despite the obvious skill of the painter, the decisive factor in confirming the frame's existence for us is our own expectation that we will see frames around pictures. Everywhere we go—museums, galleries, restaurants, public spaces, hotel rooms, our own homes—wherever there is a painting, it is usually in a frame. If we wonder why a painting of the Garden of Eden is without a frame, we can convince ourselves that it is not.

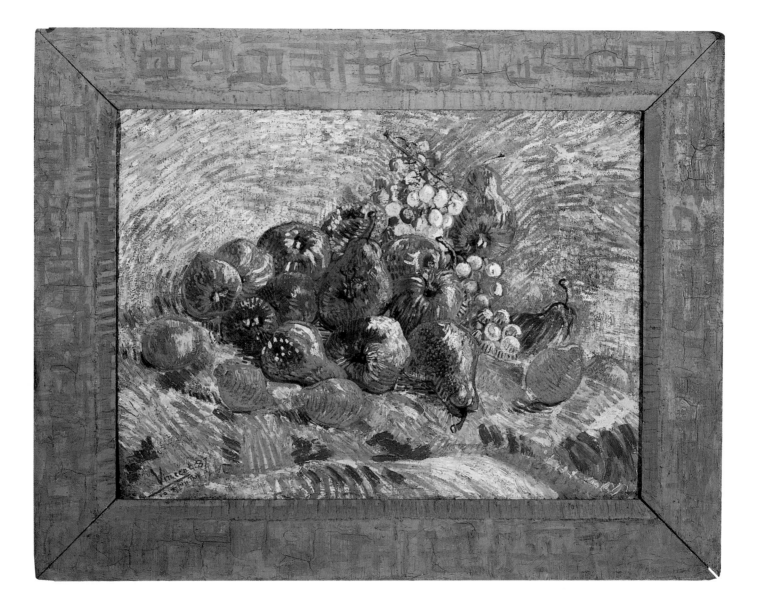

Only one frame made by Vincent van Gogh has survived the ravages of taste, ignorance, and war. Fortunately, this frame is in excellent condition and surrounds the painting for which it was made, a still life dedicated to the artist's brother, Theo. This surviving example affords us an opportunity to study van Gogh's unique solution to the problem of framing his own idiosyncratic work.

Like the artist's work, this frame's most striking characteristic is its visual directness. It is simple in construction: four flat boards about three inches wide, beveled toward the painting at the inside lip and joined with mitered corners. What is unique are the brushmarks and brilliant colors that enliven the surface of the frame, emphasizing its basic form, so that the frame becomes both an extension of and a container for the painting. Two different shades of chrome yellow are applied to the four boards—one a thick, underlying warm tone that covers the entire surface, the other cooler but of equal value. Short hatchmarks form a grid reiterating the rec-

Van Gogh's letter to his brother, November 12, 1888

tangular shape of the canvas and giving a glittering, rhythmic quality to the surface. The values of these yellows are tightly controlled to form a unified surround for the painting, enabling the dark and light yellows of the image to create a sense of dramatic form and dynamic movement.

The two tones of the frame are also used on the thin, beveled lip, but here the brushstrokes have been applied in alternating rows of color. They lie at right angles to the picture and coat the full width of the bevel, creating a forced perspective that guides the viewer's eye into the still life. Once our eye slips inside this beautiful picture, the golden halo around it—van Gogh's unique painted interpretation of a gold-leaf frame—compels us to linger and enjoy the sun-ripened fruit.

Alexander Calder liked to have fun. But it was fun without fooling—serious fun that makes you think while you laugh. Surrounding one of his largest early motorized pieces is the component that gives this work its title. This frame functions as a proscenium and sets the stage for all the activities that take place within (and beyond) its confines. However, it is a stage with no floor, backdrop, or curtain. The "performance" is a dance by a corps of various circles that explore varieties of movement. The dancers include two spheres, a ring, and a round pendulum, all four suspended at different lengths from the top bar of the frame. Another member of the troupe is a diagonal spiral wire placed at the left, which pivots on the bottom sight edge of the frame. A small vertical rectangle, an outsider, hangs in the shallow "orchestra pit" below the frame. Each of these performing elements is set into motion through the use of motors, pulleys, and cams.

Calder made several of these motorized reliefs to explore an aesthetic problem raised by his non-figurative paintings. Why should one placement of a form within a composition be better than another? Here he could experiment, making the forms occupy a variety of positions and still be satisfying. The two spheres and the ring each twirl at a different rate, while the spiral winds up and down in space and the pendulum swoops in its arc, traveling in front of and outside the right panel of the frame. Not only can the individual forms occupy several positions in this composition, but one of them is able to escape, if briefly, the confines of the proscenium.

In this series of six lithographs, Hockney is clearly amused by Hollywood collectors and the ways in which they frame their pictures. He has presented each image in a frame, but drawn both picture and frame on the same sheet as if they were a single object. The titles include a reference to the frame as well as the image, as in *Picture of a Pointless Abstraction Framed under Glass* or *Picture of Melrose Avenue in an Ornate Gold Frame*.

Hockney has provided versions of the standard artistic genres: still life, landscape, portrait, nude, and abstraction. Each conveys the artist's characteristically witty, graphic sensibility, but underlying this directness is a comment on Hollywood's fondness for display, and this is where the frames come in. *Gold, silver, elaborate, ornate*—each of these words used by Hockney to describe the frames is part of a stereotype of Hollywood taste. The frames depicted live up to their billing as high-end home decor.

Hockney uses only three frame designs for the six different images: Louis XVI-style French, with its typical fluted panel and delicate row of interior beading; Spanish, with bold carving on the inside and outside of the wide black panel; and a very thin, nondescript modern frame. By using the lithographic process, Hockney is able to apply any of the frame types to the pictures, and he has chosen to use each of the three twice, once in silver and once in gold.

Part of the delight in viewing this group is seeing Hockney's matching of frame to picture. The two French frames provide very different visual experiences when given different colors and superimposed on dissimilar pictures. In *Picture of a Still Life That Has an Elaborate Silver Frame,* the frame harmonizes perfectly with the cool, gray tones that dominate the picture and provide a setting for the two brilliant red flowers. The frame size in *Picture of a Landscape in an Elaborate Gold Frame* gives formality and strength to the centered, robust tree, and the gold echoes the sunlight moving through the leaves.

Two pieces—*Picture of a Portrait in a Silver Frame* and *Picture of Melrose Avenue in an Ornate Gold Frame*—share the same Spanish-style frame but to completely different effect. The man in the portrait seems incapable of living up to the grandeur and vitality of his frame and appears lost in the plain, solid-blue background. The Melrose Avenue sign and its surroundings are exalted to landmark status by the rich gold and black museum-quality frame. This is an appropriate choice for the ennoblement of an eccentric Hollywood locale, as Melrose Avenue was when the print was made in 1965.

The most interesting picture in the series may be *Picture of a Pointless Abstraction Framed under Glass.* Hockney, whose issues with abstract painting are well known, has written: "Some artists need subjects more than others, but you can play down the subject too much; there is an importance in it." Although he notes in the title that his abstraction is "pointless," the image is very accomplished and would be considered by many an acceptable work of the genre. However, the real subject of this work is not the color image but the glass that covers it. The subtle use of tone, highlights, and lines describes keenly observed characteristics of light playing over a glass surface, a subject Hockney has investigated many times. The silver frame holds the glass, which technically lies in front of the image and is not supposed to be seen, contributing to the illusion of reflections. In this case, highlights dominate the picture and force our eyes to move all over the surface.

The series as a whole satirizes the use of overblown, inappropriate frames to inflate the significance of simple genre pictures. By extension, this group also brings up the question of just what is an appropriate frame for each of these genres and especially, with tongue in cheek, what frame is appropriate in the context of Hollywood. It is, of course, no accident that the frames and pictures used to illustrate this aesthetic inquiry go so well together. The artist has drawn them both, controlling exactly how much give-and-take was needed between picture and frame in order to achieve an ironic compositional harmony.

Jim Nutt makes frames for virtually all of his paintings. These frames, which always display a love of craft, are sometimes simple and elegant and sometimes elaborate and neo-baroque, like the ones surrounding this double portrait. Nutt has often come up with unconventional ways of expressing his ideas; here, for example, he has played with a traditional format—the stand-alone diptych—to produce a unique result.

These small portraits, supported by fold-up easels on the back, also mimic the family photographs commonly found on living-room pianos, mantels, and coffee tables, framed in anything from period reproductions to glue-gun concoctions. With these two frames, Nutt takes the opportunity to create forms that are metaphors for the nightmarish relationship that surely exists between this couple. The frames elaborate on the distorted image types for male and female that Nutt has developed over the years.

The base beneath each portrait, a parody of glitzy "decorator" style, resembles the tread mechanism of an army tank and is painted with subtle highlights that add an illusion of movement as the man and woman in the portraits confront each other, about to collide head on. The woman's head is surrounded with a frame of spiky black shapes, like shark fins, interspersed with blue wedges that suggest a whirlpool and create dynamic movement at the sides. At the top is a strange brown figure that may (or may not) be a wrapped figure of Victory. The man's portrait is surrounded with organic forms (bones? penises? worms?) that appear to be covered with tar and lashed to the frame, a graphic representation of suppressed desires and needs. Small brown body parts float among the black forms at the top.

Nutt has given us a glimpse at the psyches of his subjects in the Renaissance-inspired predella panels above each portrait. Above the woman's head, in a horizontal panel, is a vaguely pornographic image of a female on all fours, flanked by tiny portraits of a man and woman who are scrutinizing us, as if to gauge our reaction. Above the man's portrait is a panel containing three elements: an animal skull with floppy ears and a winged woman's head resembling a Renaissance angel on either side of a male torso wearing a tightly zipped leather jacket. These cryptic images seem to expose the crackling brain waves flowing between this antagonistic pair.

The backs of these portraits contain patterns and phrases that complement the imagery on the front: "something's Not quite right!" on the man's portrait, with "Braced for the occasion by Jim Nutt" on the easel. On the woman's portrait is written "it doesn't Bother her" and on the easel, "stand up by Jim Nutt." The diptych does not tell a pretty tale, exposing to us the entrails of a relationship, something that is often disturbing to witness. Interestingly, the frames are what define the relationship between the two individuals by telling us what lies behind the stylized portraits.

Frank Stella's 1963 Purple paintings exemplify one phase of a logical evolution in thinking that he initiated in the late 1950s. As a newcomer on the New York scene, Stella challenged conventional thinking about contemporary painting. He set out to effect a rapid and radical reorganization of the priorities of picture making, confronting the basic functions of the frame in the process. He gave the frame edge of the canvas a dominant role in determining the painting's content. A pair of seemingly unrelated factors helped determine the direction of Stella's work during this period.

The first was his desire to distance himself from the emotive and improvisational approach of the Abstract Expressionists, who were in ascendancy at the time. To this end, Stella determined to remove any emotional content from his own work. He sought to focus on a primary idea in each painting and to arrive at an overall composition that was immediately delivered to the viewer, devoid of illusionist depth—a flat field without degrees of subtlety, equally important in every part.

A second, more mundane factor was the simple economic imperative of affordable materials. Instead of buying one-inch stretcher bars, Stella bought the cheapest lumber he could find, which was three inches thick. When mounted on a wall, the stretched canvas on these thicker bars did not recede into the wall plane but asserted its independence from that plane as a discrete architectural unit. The shadows cast on the wall by the deep projection helped reinforce the painting's new identity as a large, autonomous rectangle with its own singular broad, flat surface, a surface Stella determined to exploit to the fullest.

In 1959–60 he developed a series of huge pictures that came to be known as the Black paintings. Using black house paint on traditionally rectangular white canvases, Stella produced images that were symmetrical and emblematic. Between the flatly applied bands, he left a ⅛-inch strip of unpainted white canvas. The edge of the canvas, therefore, became the determining factor of the composition, creating what the artist has called "non-relational" paintings.

In *Avicenna* (1964), which has diminutive notches in each corner, the vertical sides of the frame edge determine the picture's stripes. At the center the artist made a small rectangular opening in the canvas, allowing the wall to show through. Although the depth of the stretcher bars created shadows that cover the exposed wall and obscure the view, this innovative idea led the artist to explore the use of the central opening in his Purple paintings.

These paintings are polygonal structures: a triangle, a trapezoid, an octagon, and so on. As in *Avicenna*, a hole has been made in the center of the canvas but this time it is equal to one half the painted surface. The shape follows the frame edge of the polygon and its parallel painted bands, so that the hollow core of the picture exposes the wall in the same shape as the painting. With these works, Stella completely subverted the usual relationship between picture and frame by making them one and the same.

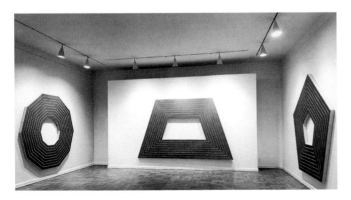

Installation of a Stella exhibition at the Castelli Gallery, New York, 1964

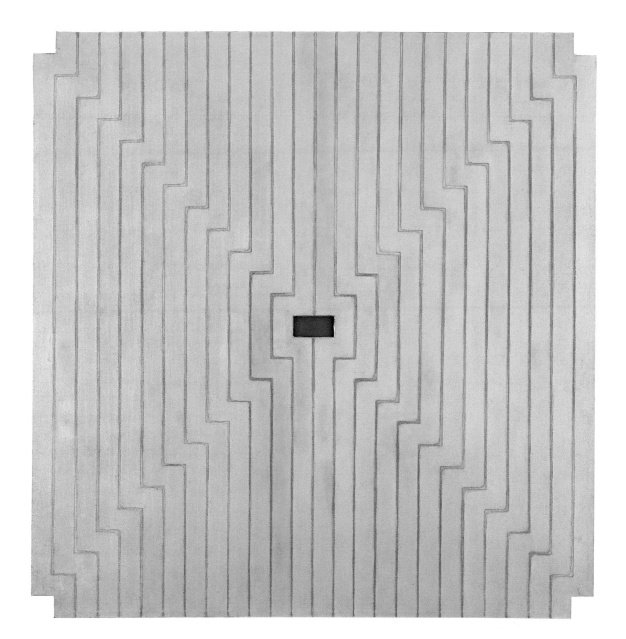

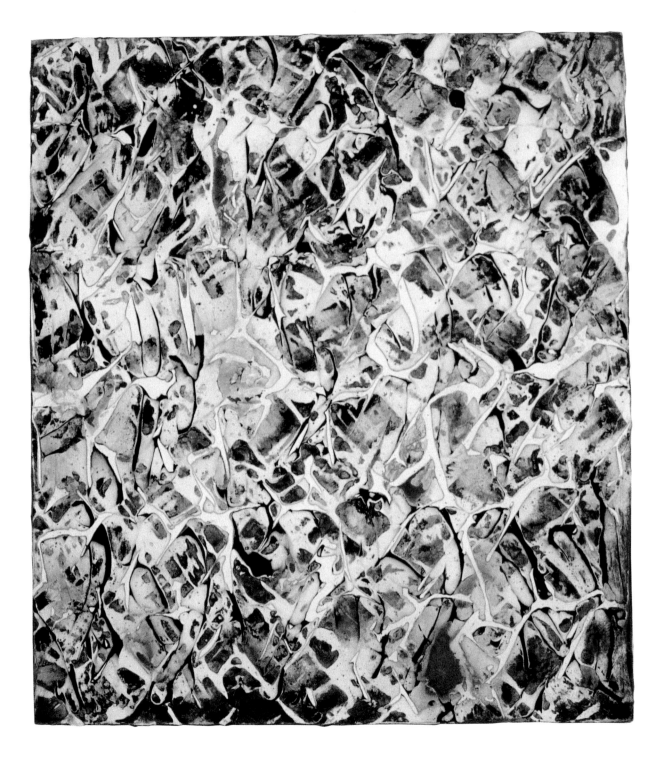

Gelfman is an artist concerned with a nontraditional presentation of her work, which she investigates in a particularly resourceful way. She has a number of paintings in progress in her studio at any given time, and she is meticulous about recording the progress of each piece by making sure that every layer of color, as it is applied, is allowed to flow over the edge and leak down the sides, which are two and one-half inches deep. When you enter an exhibition of Gelfman's paintings, you are immediately aware of these edges, which invite you to come closer and become more intimate with the painting. This is a dramatic and welcome contrast to most contemporary exhibitions, where the thick stretcher bar wrapped in white canvas is used only as a stylistic device without any consideration of visual distraction.

Gelfman's work ranges from whispers to shouts, exquisite to turbulent, often within the same group of works. Using textures and layers, she reworks repeatedly, building up a complex skin, sanding between layers, piling paint, scraping it off, dripping it on, mushing it with a palette knife, infusing it with chemicals and solvents in a process that may take weeks, until the work is complete. The frame edge, as it accumulates various colors, textures, and drips of overlapping elements, becomes a working record of all the ingredients that have been used in making the work, a visual journal of the process that created the piece. The sides and the front of the painting usually end up bearing little resemblance to one another, just as the appearance of the ingredients used to make a cake give no indication of what the finished cake will look like. Gelfman's recent work is rectangular and not large, so that you can see an entire painting at close range. The deep sides bring the picture surface well out from the wall, inviting close scrutiny, which increases the potential for intimate dialogue between viewer and picture. Often the artist arranges her work at at eye level in groups of three or five, with evenly measured spaces between them so that one's attention can shift easily between gathered pieces and yet view each picture independently. Other paintings may be displayed alone, above or below eye level, where the frame edge, top or bottom as well as sides, calls for attention.

Playing the traditional role of a frame as mediator, the edges make us notice the painting's physical presence and complement the picture surface by offering visual counterpoint to the work, but they do so without the addition of any structure. The artist has managed to retain an essential function of the frame by eliminating it altogether.

Jasper Johns has said about his art that the viewer has a responsibility to participate actively in the exploration of the ideas the artist presents. A similar obligation faces anyone who wishes to expand his or her experience of looking at paintings beyond the limitations set by most art publications, which customarily present works of art surrounded by white margins devoid of context. Although much has been written about masterpieces, ancient to contemporary, little is mentioned of the frames that surround them, although if they are well chosen, they can add immeasurable pleasure to the viewing experience, just as frames of spectacular quality and character can give mediocre paintings distinction. Ortega y Gasset has noted that the walls on which paintings hang are usually drab and utilitarian by comparison. It is the frame, not the wall or the art, that creates a window of escape that compels us to leave the plain vertical surface and move into an imagined realm, the unique world of the artist's vision.

acanthus stylized classical motif based on the leaf of the acanthus plant

antependium shaped lower extension to a tabernacle frame, usually ornamented and symmetrical across the vertical axis. The term derives from the cloth that hung across the altar.

architrave group of raised moldings on the lower side of an entablature

bole clay undercoat on gesso layer beneath gilding

cartouche decorative frame resembling a shield or scroll, often outlined by scrolls or scrolled foliage

cassetta frame frame with a flat panel and raised inner and outer moldings

coffer decorative sunken panel in a vault, dome, or ceiling

compo a form of modeling paste used to make heavily decorated frames (eventually replaced by plaster of Paris)

corbel architectural support that projects up and out from a vertical surface

cornice group of raised moldings on the upper side of an entablature

cove quarter-circle concave molding

dentil carving rectangular molding carved into a series of small blocks resembling teeth

diptych two panel paintings hinged or attached together

ebonized stained or painted black and polished to give the appearance of ebony

egg-and-dart classical ornament of alternating ovals and pointed motifs used to enrich a convex molding

entablature horizontal area supported by columns and consisting of architrave, frieze, and cornice

fillet narrow, flat step between the moldings of a frame

finial three-dimensional architectural ornament usually at the top of a spire or gable

fretwork geometrical pattern of intersecting horizontal and vertical bands

figure-ground design term used to connote the relationship between an object and its background

CASSETTA FRAME

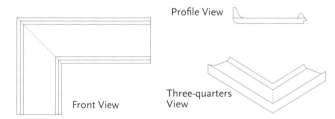

Profile View

Front View

Three-quarters View

frieze series of decorations forming an ornamental band on a surface

gesso compound of plaster or chalk and glue used to prepare a surface for painting or gilding

grotesque intricate and fanciful decoration made up of foliage inset with animals, birds, or figures

lunette arched unit at top of a frame, filled with painted or carved decoration

miter surface of the edge of a piece cut at an angle to fit together with another piece in a miter joint

palmette classical stylized palm leaf ornament

passe-partout method of framing that involves the use of a mat, glass, and a backing to protect a picture

pilaster rectangular vertical pier or flattened column

plinth substructure supporting a column

predella part of the base of an altarpiece or tabernacle frame divided into panels decorated with paintings

presentation painting a work that demonstrates the acquired skills of an apprentice about to become an independent master painter

profile section view of a molding when sliced front to back

profile rim the inside or outside edge of a tondo frame

retablo Spanish-type altarpiece consisting of a large frame filled with carved or painted scenes

ribbon-and-stick thin convex molding or dowel in the form of a ribbon spiraled around a narrow stick, often an ornament at the top edge or sight edge of Neoclassical frames

sight edge the inner edge of the frame nearest to the picture

swag garland of flowers, fruit, or foliage

tabernacle frame architectural surround to a painting that was originally an ornamental niche above an altar

tessera small, square piece of marble or glass used in mosaic work

tondo frame with circular sight and back edges

torus molding convex molding, usually the lowest in a column base

tracery ornamental work of interlacing or branching lines at the top of Gothic altarpieces

triptych three panel paintings hinged together or attached; the center panel is usually largest, flanked by smaller side panels, or wings

trophy frame frame decorated with trophies, or symbolic objects relating to the subject of the work

volute spiral scroll ornament derived from the Ionic column

TABERNACLE FRAME

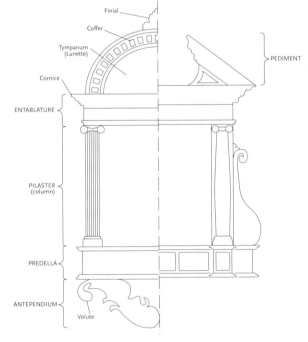

Finial
Coffer
Tympanum (Lunette)
Cornice
PEDIMENT
ENTABLATURE
PILASTER (column)
PREDELLA
ANTEPENDIUM
Volute

BIBLIOGRAPHY

Arnheim, Rudolf. *Art and Visual Perception: A Psychology of the Creative Eye*. Berkeley and Los Angeles: University of California Press, 1954.

Brettell, Richard R. and Starling, Steven. *The Art of the Edge: European Frames 1300–1900*. Chicago: Art Institute of Chicago, 1986.

Duro, Paul, editor. *The Rhetoric of the Frame: Essays on the Boundaries of the Artwork*. Cambridge: Cambridge University Press, 1996.

Gombrich, E. H. *Art and Illusion: A Study in the Psychology of Pictorial Representation*.
Princeton: Princeton University Press, 1989.

Grimm, Claus. *The Book of Picture Frames*. Norwalk, Conn.: Abaris Books, 1992.

Mendgen, Eva, editor. *In Perfect Harmony: Picture and Frame 1850–1920*. Amsterdam: Van Gogh Museum, 1995.

Mitchell, Paul and Roberts, Lynn. *Frameworks: Form, Function & Ornament in European Portrait Frames*. London: Merrell Holberton, 1996.

Newberry, Timothy J., George Bisacca, and Laurence B. Kanter, *Italian Renaissance Frames*. New York: Metropolitan Museum of Art, 1990.

Simon, Jacob. *The Art of the Picture Frame: Artists, Patrons and the Framing of Portraits in Britain*. London: National Portrait Gallery, 1996.

Thornton, Peter. *Form & Decoration: Innovation in the Decorative Arts 1470–1870*. New York: Harry N. Abrams, 1998.

Fund, 1946; PAGE 50: Ferdinand Bol, *Self-Portrait*, ©Rijksmuseum, Amsterdam; PAGE 51: Jean-Auguste-Dominique Ingres, *Mme. Moitessier*, National Gallery, London; PAGES 52–53: James Abbott McNeill Whistler, *Variations in Pink and Gray*, Courtesy of the Freer Gallery of Art, Smithsonian Institution, Washington, DC; PAGE 55: Ustad Mansur (attrib.), *Emperor Jahangir*, Victoria & Albert Museum, London (photo: V&A Picture Library); PAGE 56: Theodore Roussel, *Anemones*, Victoria and Albert Museum, London (photo: V&A Picture Library); PAGE 60: Joseph Siffrein Duplessis, *Benjamin Franklin*, The Metropolitan Museum of Art, New York, The Friedsam Collection, Bequest of Michael Friedsam, 1931; PAGE 63: Thomas Eakins, *Professor Henry A. Rowland*, ©Addison Gallery of American Art, Phillips Academy, Andover, MA; PAGE 64: Florine Stettheimer, *Portrait of Marcel Duchamp*, Philadelphia Museum of Art; PAGE 67: Cindy Sherman, *Untitled*, Courtesy Cindy Sherman and Metro Pictures; PAGE 68: Edward Hicks, *The Falls of Niagara*, Abby Aldrich Rockefeller Folk Art Museum, Williamsburg, VA; PAGE 69: William Hawkins, *Niagara Falls*, Ricco-Maresca Gallery/Art Resource, NY; PAGE 70: Paul Klee, *Ad Marginem*, Oeffentliche Kunstsammlung Basel, Kunstmuseum ©Artists Rights Society, New York (photo:Oeffentliche Kunstsammlung Basel, Martin Bühler); PAGE 73: Alexis Smith, *Route 66*, private collection (photo Douglas M. Parker Studio, courtesy Margo Leavin Gallery, Los Angeles) ;PAGE 74: James Earle, Presentation Frame to Friendship Engine Co., CIGNA Museum and Art Collection, Philadelphia; PAGE 76: Horace Pippin, *The End of the War: Starting Home*, Philadelphia Museum of Art, Given by Robert Carlen; PAGE 77: Greg O'Halloran, *Tsunami*, ©Greg O'Halloran; PAGE 81: Joan Miró, *Portrait of a Man in a Late Nineteenth-Century Frame*, The Museum of Modern Art, New York, Gift of Mr. and Mrs. Pierre Matisse, ©Artists Rights Society, NY; PAGES 82–83:Larry Rivers, *Jim Dine Storm Window Portrait* (3 positions), ©Larry Rivers/licensed by VAGA, New York; PAGE 85: Tadanori Yokoo, *John Silver*, Collection Laurie B. Eichengreen and W. H. Bailey, © Tadanori Yokoo; PAGE 87: Raymond Saunders, *Untitled*, private collection © Raymond Saunders; PAGE 88: Frida Kahlo, *Fulang-Chang and I*, The Museum of Modern Art, New York, Mary Sklar Bequest; PAGE 89: Betye Saar, *Watching*, ©Betye Saar, Courtesy of Michael Rosenfeld Gallery, New York; PAGE 92: Edgar Degas, Frame profiles and studies, ©Bibliothèque Nationale, Paris; PAGE 93: Edgar Degas, *The Collector of Prints*, The Metropolitan Museum of Art, New York, H.O. Havemeyer Collection, Bequest of Mrs. H.O. Havemeyer, 1929; PAGE 95: Georges Seurat, *Poseuses*, Barnes Foundation, Merion, PA, © 1998 The Barnes Foundation; PAGE 96: Gustav Klimt, Sketches for the frame of *Judith I*, © Osterreichische Galerie Belvedere, Vienna; PAGE 97: Gustav Klimt, *Judith I*, © Osterreichische Galerie Belvedere, Vienna (photo: Photograph Erich Lessing/ Art Resource, NY); PAGE 98: Photograph of Gluck exhibition, Fine Arts Society, London (photo courtesy Fine Arts Society); PAGE 99: Hannah Gluck, *Self-Portrait*, National Portrait Gallery, London; PAGE 100: Letter from Maurice to Charles Prendergast, Williams College Museum of Art, Prendergast Archive and Study Center, Gift of Mrs. Charles Prendergast; PAGE 101: Maurice Prendergast, *Landscape with Figures*, Munson-Williams-Proctor Arts Institute, Museum of Art, Utica, NY; PAGE 102: Jan Toorop, *The Frame-maker Joosstens*, Gallery Frans Leidelmeijer, Amsterdam; PAGE 105: Henri Matisse, *The Red Studio, Issy-les-Moulineax*, The Museum of Modern Art, New York, Mrs. Simon Guggenheim Fund (photo: © 2000 The Museum of Modern Art, New York), © Succession H. Matisse, Paris/ Artists Rights Society, NY; PAGE 106: Piet Mondrian, Sketchbook PAGE, Gemeentemuseum, Netherlands, ©Artists Rights Society, NY; PAGE 107: Piet Mondrian, *Composition with Red*, Philadelphia Museum of Art, A.E. Gallatin Collection, ©Artists Rights Society, New York; PAGE 109: Salvador Dalí, *Couple with their heads full of clouds*, Collection Museum Boijmans van Beuningen, Rotterdam, © 2001 Salvador Dali, Gala-Salvador Dali Foundation/Artists Rights Society, NY; PAGE 110: Jasper Johns, Instructions, © Jasper Johns/Licensed by VAGA, New York, NY; PAGE 111: Jasper Johns, *Dancers on a Plane; Merce Cunningham*, Tate Gallery, London/Art Resource NY; © Jasper Johns/Licensed by VAGA, New York, NY; PAGE 114: Charles Willson Peale, *Staircase Group*, Philadelphia Museum of Art, George W. Elkins Collection; PAGE 115: William Harnett, *Still Life: Violin and Music*, The Metropolitan Museum of Art, New York, Catharine Lorillard Wolfe Fund, 1963; PAGE 116: Erastus Salisbury Field, *The Garden of Eden*, © Shelburne Museum, Shelburne, VT; PAGE 118: Vincent van Gogh, *Still Life with Fruit*, Van Gogh Museum, Amsterdam (photo: Vincent Van Gogh Foundation); PAGE 119: Vincent van Gogh, Letter to his brother, Theo, Van Gogh Museum, Amsterdam (photo: Vincent Van Gogh Foundation); PAGE 120: Alexander Calder, *The White Frame*, Moderna Museet, Stockholm, Sweden; ©Artists Rights Society, NY; PAGES 122–23: David Hockney, A Hollywood Collection, Lithograph in seven colors from edition: 85, © David Hockney; PAGE 124: Jim Nutt, *He Might Be a Dipdick, But They Are a Pair* (front and back views), private collection, ©Jim Nutt; PAGE 126: Installation photograph of Stella exhibition at Castelli Gallery, New York; PAGE 127: Frank Stella, *Avicenna*, private collection, © Frank Stella/Artists Rights Society; PAGES 128–29: Lynne Golob Gelfman, *Bloodlet*, private collection, © Lynne Golob Gelfman

ACNOWLEDGMENTS

Somebody once said that seeing what is in front of you is one of the most difficult things to do. Three teachers deserve special credit for training my eye and mind to reap the rewards of enthusiastic looking: Joseph "Fitz" Fitzpatrick, Robert Lepper, and Roger Anliker.

Thanks go to Dorothy and Stephen Globus for introducing me to Eric Himmel, Editor in Chief at Harry N. Abrams, to whom I am grateful to for believing in the kernel of an idea, jump-starting the book, and endorsing a first-time author through a long gestation period. Barbara Burn, senior editor, sowed the idea for a book about frames and became (lucky me) my editor. She has given generous support, guidance, and help throughout the intricacies of the growing of this book with the aid of her assistant, Josh Faught. Like the avid gardener that she is, Barbara applied her knowledge of nourishing, weeding, shaping, and pruning, and she rejoiced when buds and the occasional blossom appeared.

Jeannie Hutchins, my skilled navigator from the moment the project took off, kept me and my primitive writing skills on course with a never-wavering assurance that the destination was not only reachable, but that a rich and rewarding, even jocular, passage was possible. It was a longer journey than we expected, but she was right.

Many colleagues and friends in the frame and art field gave unstintingly of their time to help me, generously sharing their expertise. I single out Sam Varnedoe for his lightning swift editorial sword, amazing precision with the meaning of phrases, and his whole-hearted zeal for the book, particularly in times of need. Susan Lorence gave me access to her extraordinary library and read the manuscript, offering valuable comments based on her personal and professional involvement in the visual arts. Jed Bark of Bark Frameworks, a collaborator on many projects, shed light with his rye humor on a number of murky issues and enabled me to present material that might never have seen light. Roger Ricco of the Ricco Maresca Gallery took considerable time to share with me his knowledge about William Hawkins.

Much appreciation goes to Keith Christiansen at the Metropolitan Museum of Art for expediting special requests, and very special thanks to George Bisacca, whose enthusiasm for Tom Waits's music I share but whose knowledge and erudition about frames I can only try to emulate. His willingness to share with me his keys to the kingdom has given this book a special character.

Thanks to compatriots who gave constant encouragement: Deborah Bull and Susan Wechsler, whose impromptu calls to find out how "it" was going lifted my spirits every time; Bob Bull for his sense of humor and unique perspective on life and books, without which this project would have been a much duller endeavor; Koos van den Akker, always a positive force in my life, for introducing me to Puck Meunier whose delightful spirit made her valuable translations of Dutch material a pleasure to interpret. The staff at Carousel worked long and hard to obtain the images for this book, a difficult job with such a wide range of material.

For the refreshing, insightful design of this book appreciation goes to Eric Baker of the design firm that bears his name, and his colleague Sam Potts. It was fortuitous that chance brought Eric and me together again after too long a separation.

No author could be more pleased with a foreword than I am. Thanks, Adam.

This book would not have been possible to undertake and sustain to completion without the multifaceted support of my love and lifemate, Laurie B. Eichengreen.

W. H. Bailey

INDEX